Pablo Picasso

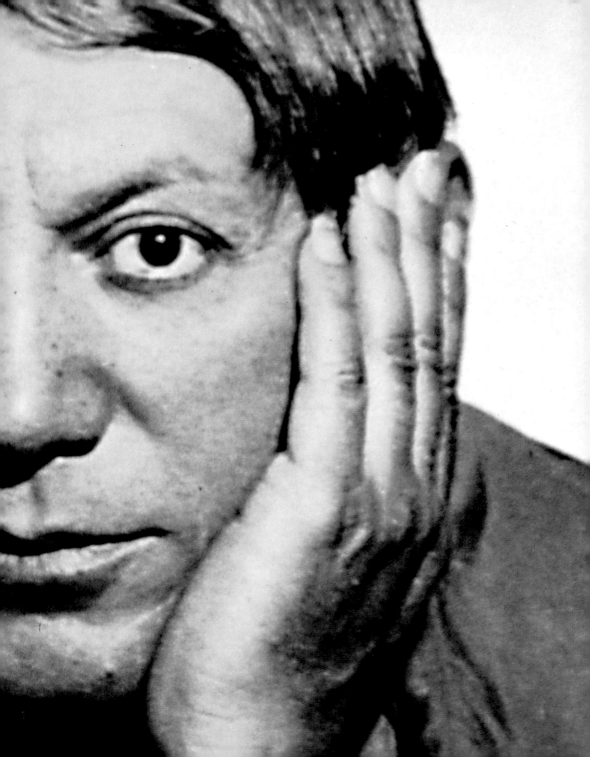

Pablo Picasso

Life and Work

Elke Linda Buchholz
Beate Zimmermann

BARNES
&NOBLE
B O O K S
NEW YORK

Early Years
Page 6

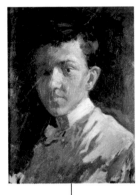

Arrival in Paris
Page 12

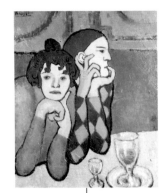

The Blue Period
Page 20

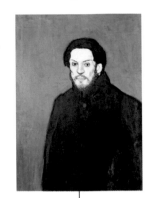

1881 **1890** **1900** **1905**

1930 **1935** **1940**

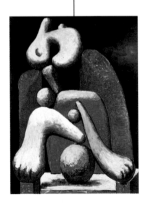

Surrealism
Page 54

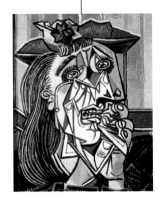

The "Barbarian" Years
Page 64

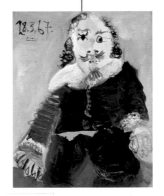

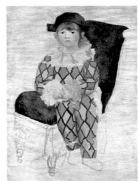

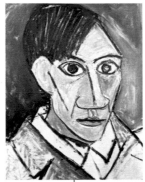

1910 **1915** **1920** **1925**

1950 **1960** **1973**

Even when he was very young, the exceptional talent of Pablo Ruiz Picasso attracted attention. This was fortunate because he hated schoolwork and, according to his own account, learnt nothing at all at school. As a child he loved to spend his time drawing. His father, who was a painter and a teacher of drawing, soon recognized his son's talent and supported him in every way he could.

This early encouragement, together with his father's practical lessons in drawing and painting, enabled Picasso to complete the standard academic art training in an unusually short time, and to achieve his first successes in official art exhibitions before he was 21. Although he was soon to reject the academic tradition, the solid technical training he received provided the firm foundation for his astonishing artistic development.

Important themes such as doves, bullfighting scenes, as well as self-portraits, which recur constantly in his work, have their origins in this period of his life.

The Statue of Liberty in Paris, 1886

Picasso at the age of 15

1882 Triple Alliance between Austria, Italy, and Germany formed.

1883 Death of Edouard Manet.

1888 William II becomes Emperor of Germany.

1890 Death of Vincent van Gogh.

1891–1906 Dreyfus Affair in France.

1895 Invention of film; discovery of X-rays.

1881 Pablo Ruiz Picasso born on October 25 in Málaga, the first child of Don Jose Ruiz Blasco and his wife Doña Maria Picasso Lopez. His father is a painter and teacher of drawing at the local school of arts and crafts.

1888–89 Picasso begins to paint under the tuition of his father; he produces his first oil painting.

1892 He enters the art school at La Coruña.

1895 He moves to Barcelona and enters the academy of art "La Lonja", where his father teaches.

Opposite:
Self-Portrait with Short Hair, 1896
Oil on canvas
46.5 x 31.5 cm
Barcelona, Museu Picasso

Right:
Doves, 1890
Pencil on paper
22 x 10.5 cm
Barcelona, Museu Picasso

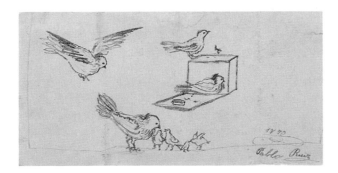

**Portrait of the
Artist's Mother**, 1896
Watercolor on paper
18 x 12.5 cm
Barcelona, Museu
Picasso

**Portrait of the
Artist's Father**, 1896
Oil on canvas on
cardboard
42.3 x 30.8 cm
Barcelona, Museu
Picasso

The young Picasso
made innumerable
portraits of his
parents. In doing so
he was training
himself in various
pictorial techniques,
and in particular
learning exactly how
to reproduce the
subtle effects of light
and shade. He was
soon in a position to
capture not just the
outward appearance
of his sitters but also
their character.

Childhood

Pablo Ruiz Picasso spent his childhood in the middle-class, art-loving environment of a respectable, though not wealthy, family. He was born on October 25, 1881 in Málaga, a provincial town in southern Spain, the first son of Doña Maria Picasso Lopez and Don José Ruiz Blasco. As is customary in Spain, he used the surnames of both parents, and it was not until 1901 that he decided to use only his mother's name. His father worked as a restorer at the museum in Málaga and gave drawing lessons at the art school. "My father painted pictures for the dining-room; partridges and doves, doves and rabbits; you could see the fur and the feathers," Picasso recalled later. "There were always doves around; they were sitting in the dovecote or flying around in the open air, and they were captured in the dining-room pictures." Along with this love of doves, Picasso also inherited his father's passion for bullfighting; father and son often went to see fights together.

Don José, whose abilities did not extend beyond rather mediocre

animal paintings and still lifes, planned an ambitious career for his highly talented son, a career as a respected painter of figures and history paintings. As a start, he himself instructed his son in the basics of precise drawing, and soon put a brush in his hand. As early as 1892, the 10-year-old Picasso passed the admission examination at the art school in the small northern Spanish town of La Coruña, where his father was now teaching. In 1895 the family moved to the lively port of Barcelona, since his father could earn more money at the art academy there. But far from his home and friends, Don José became more and more melancholy and finally gave up painting altogether. His gifted son, by contrast, was one of the advanced students at the academy, achieving an impressive command of artistic techniques. In 1897 Picasso, with the financial support of his family, moved to Madrid to continue his studies. The instruction there, however, bored him so much that he preferred to roam the streets and squares observing people, and to visit the Prado to study the paintings of the great Spanish artists El Greco and Velázquez.

If you become a soldier, you will be a general. And if you become a monk, you will be the pope.

Picasso's Mother,
Doña Maria Picasso Lopez

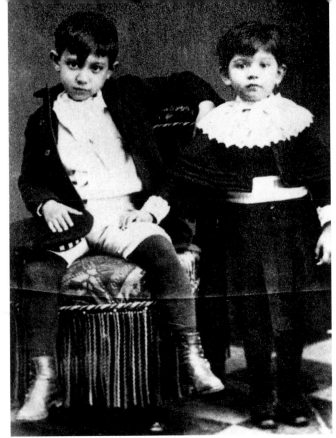

The seven-year-old Pablo Ruiz Picasso and his sister Dolorès, 1888
Anonymous photograph

The house where Picasso was born, in Málaga
Anonymous photograph
The family apartment was in the Plaza de la Merced, not far from the city center. Pablo's younger sisters, Dolorès and Concepción, were also born here.

Early Works

In a sense there are no "juvenile" drawings by Picasso. Even his earliest surviving drawings are adept and mature rather than childishly naive – clearly the training his father had provided was very sound. His paintings from his student period demonstrate that he had quickly achieved a remarkable mastery of the techniques taught on his course. In Spain, as throughout the rest of Europe, the academic education of an artist was structured in a rigidly systematic way: first students had to copy ornamental drawings; then make drawings of plaster casts; and, eventually, study the human body by drawing from a live model.

Bullfight, 1892
Pencil on paper
Barcelona, Museu
Picasso

Bullfights – as well as doves – were among Picasso's first subjects. In his later works he was to take up both themes again in various ways.

In 1896 Picasso presented his work to the public for the first time. His large-format, realistically painted works on moral or religious themes were completely in accordance with prevailing attitudes. At 16 years of age, Picasso had already learnt everything that the academies could teach him. Nothing would have stood in the way of a successful career as an academic artist.

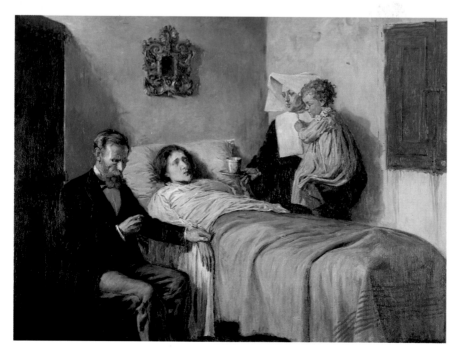

Science and Neighborly Love, 1897
Oil on canvas
197 x 249.5 cm
Barcelona, Museu
Picasso

In this very early painting by Picasso, a doctor and a nun are caring attentively for a patient – a subject which, combining moral and religious themes, was entirely in accord with the attitude of the period. It was suggested by Picasso's father, who modeled as the doctor. Picasso, then 16, successfully submitted it to an art exhibition in Madrid.

First Communion,
1896
Oil on canvas
166 x 118 cm
Barcelona, Museu
Picasso

This, the first of
Picasso's works to be
publicly exhibited,
was painted for an
important art
exhibition in
Barcelona. The lifelike
scene is carefully
composed, with
brilliant white
contrasting with red
and dark color tones.
All eyes are focused
on the kneeling girl.
As the skillful
depiction of the
transparent veil and
the almost tangible
fabric of the altar-
cloth clearly show,
this was a work
intended to display
the young artist's
abilities. The
composition also
testifies to his skill: the
lines leading
diagonally into the
image create spatial
depth, while the
directions in which
the people present
are gazing suggest a
complex structure of
human relationships.

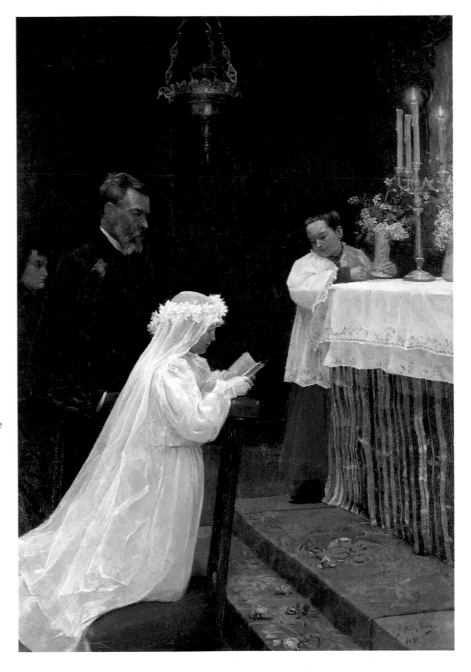

Arrival in Paris

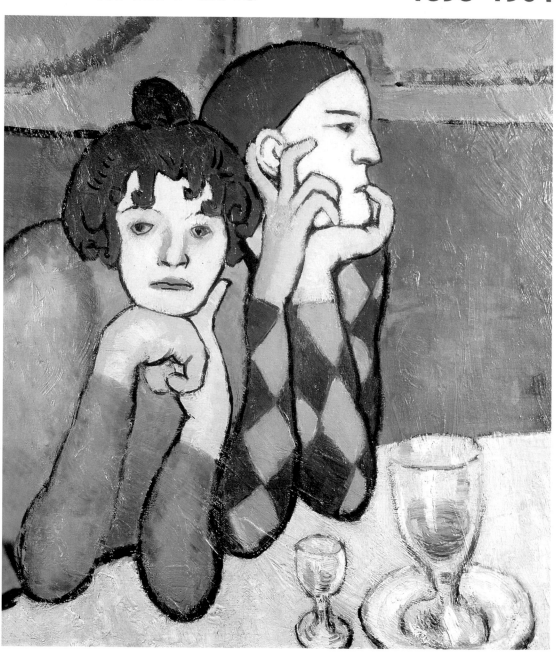

At the turn of the century, Paris was by far the most important center of the international avant-garde. Here artists and writers met in cafés and studios, and gallery owners encouraged the latest trends in art. Picasso's experience of Paris was to play a decisive role in his development. First, however, Barcelona represented an interlude on the road from academic painting to modern art. There he joined the bohemian artists in the café *Els 4 gats* (The Four Cats), who were influenced by the Art Nouveau movement. Picasso traveled to Paris for the first time when one of his paintings was chosen for the 1900 International Exhibition. In Paris he consumed art and culture avidly, painted and drew ceaselessly, and sought out other young artists; but for the time being he had to return to Barcelona. Four more years (during which he made several long trips to Paris) were to pass before he finally settled there. From then on Picasso's art was to be strongly influenced by his exposure to the art, life, and literature of Paris.

Opposite:
Harlequin and his Companion (Two Entertainers), 1901
Oil on canvas, 73 x 60 cm
Moscow, State Pushkin Museum for Visual Arts

Right:
Self-Portrait, 1898
Pencil on paper
24 x 16 cm
Barcelona, Museu Picasso

Paris, Montmartre ca. 1900

Picasso ca. 1904

1898 Spain loses Cuba and the Philippines in the war against the new world power, the USA.

1899 Death of the painter Alfred Sisley. Peace conference at The Hague for the "Peaceful Settlement of International Disputes."

1900 International Exhibition in Paris.

1901 Death of Henri de Toulouse-Lautrec.

1903 First powered flight.

1899 Picasso makes contact with artistic avant-garde in Barcelona.

1900 His painting *Last Moments* (later overpainted) is chosen for the Spanish pavilion of the Paris International Exhibition. In October, he makes his first visit to Paris. Shares studio with Casagemas in Montmartre. His first Paris painting: *Le Moulin de la Galette*.

1901 In May, he makes his second trip to Paris. Studio at 130 Boulevard de Clichy. First Paris exhibition at the gallery of Ambroise Vollard. From now on he uses only the signature 'Picasso,' his mother's maiden name.

1902 In October, he makes his third trip to Paris. Lives with the poet Max Jacob.

1904 Finally settles in Paris.

Barcelona

The year 1898 was one of upheaval for Picasso. He had given up his academic studies in Madrid and, after an extended illness, had to undergo a period of recuperation in the Spanish mountain village of Horta, where he stayed with the family of a friend.

When he returned to Barcelona, the café *Els 4 gats* became his most important point of reference, for it was there that the "Modernists," young artists and intellectuals of the Spanish avant-garde, met. The owner of the café had lived for some time in Paris and took as his model the celebrated Parisian artists' café *Le Chat noir* (The Black Cat). He organized art exhibitions, concerts, shadow theater and puppet theater, and made international

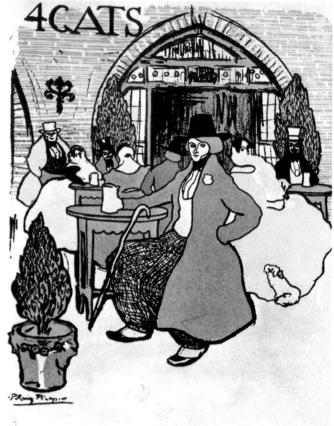

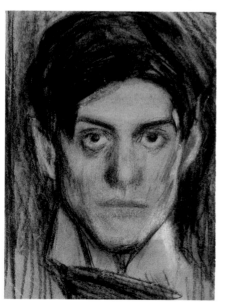

Above:
Drawing for the menu at *Els 4 gats*, 1899
India ink and gouache
22 x 16 cm
Barcelona, Museu Picasso

Left:
Self-Portrait, 1899
Charcoal on paper
22.5 x 16.5 cm
Barcelona, Museu Picasso

journals and reproductions of the latest French and German art available to customers.

Picasso was soon able to enter the circle of artists at the *Els 4 gats*. Among his closest friends were the poet Jaime Sabartés, who was later to be his secretary for many years, the painter Junyer-Vidal, and Carlos Casagemas, who shortly afterwards accompanied him to Paris. In Picasso's self-portrait from this period, a young bohemian gazes confidently at the observer, the striking

The Divan, 1899
Pastel on paper
26.2 x 29.7 cm
Barcelona, Museu
Picasso

Around 1900 Picasso's works begin to show the marked influence of the French painter Toulouse-Lautrec. Even before seeing the latter's originals in Paris, he had studied reproductions of his paintings and adopted his distinctive style. Contrasting areas of color in red and yellow, and a dynamic handling of line enhance the effect of this caricature-like scene.

Studies, 1900
India ink and colored pen on paper
13 x 20.5 cm
Barcelona, Museu
Picasso

features effectively outlined in broad strokes.

Picasso drew a great deal during this period: street and café scenes, bullfights, portraits, and sketches of his friends. For *Els 4 gats*, where his first one-man exhibition was held in 1900, he designed a menu that clearly shows the influence of contemporary Art Nouveau. Black outlines enclose areas of color in softly curving shapes, lending the image a strongly stylized character.

Picasso's First Works in Paris

In the autumn of 1900 Picasso arrived in Paris with his friend and fellow-artist Carlos Casagemas. Picasso was immediately captivated by the lively bustle on the streets and the night life in the dance bars. In hastily dashed-off drawings he explored the themes of the big city that had already been painted by the Impressionists and by Henri de Toulouse-Lautrec (1846–1901).

However, after Casagemas had taken his own life over an unhappy love affair in February 1901, Picasso became aware of the darker side of city life, and he began to paint female drunks and outcasts, people living in poverty and misery. By the autumn of 1901 Picasso's images were immersed in a melancholy blue. They reflect the contrasting sides of life in the big city.

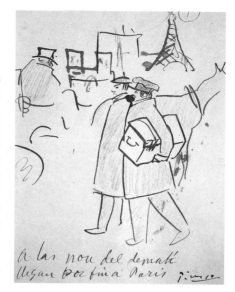

Arrival of Picasso and Junyer-Vidal in Paris, 1904
India ink and colored pen on paper
22 x 16 cm
Barcelona, Museu Picasso

"About 9 o'clock, they finally arrive in Paris."

Picasso in Montmartre, 1904
Photograph

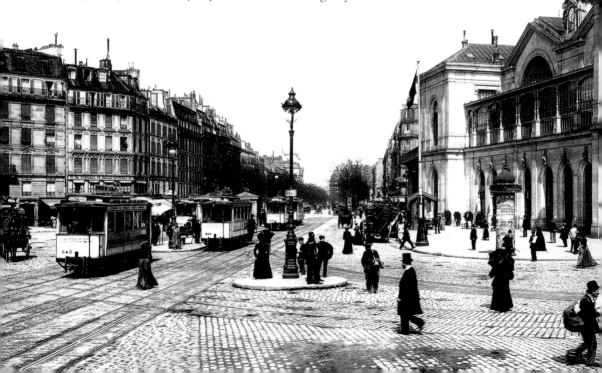

Le Moulin de la Galette, 1900
Oil on canvas
90.2 x 117 cm
New York, The Salomon J. Guggenheim Museum, Justin K. Thannhauser Foundation

The famous Paris dance bar Moulin de la Galette had already been painted by Auguste Renoir in 1876. However, as a model for Picasso, Toulouse-Lautrec's painting of the same subject of 1889 was even more significant. In the dimness of the ballroom, the figures of the dancing couples, their faces luridly lit, blaze like blurred flames of color. Three ostentatiously dressed women to the left in the foreground turn directly toward us. This picture was Picasso's first oil painting in Paris, and it shows how quickly he made the style of the French avant-garde his own.

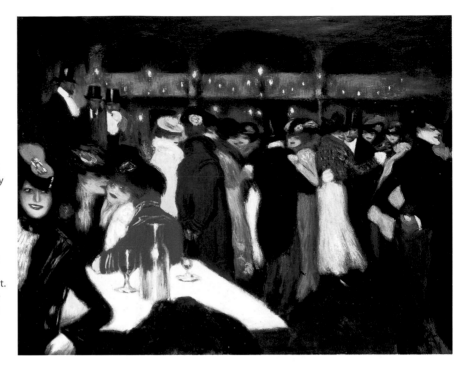

Young Girl at her Toilet, 1900
Pastel on paper
48 x 53 cm
Barcelona, Museu Picasso

As well as café and street scenes, during this early period in Paris, Picasso also painted a series of interiors, such as this pastel of a young woman in her simply furnished room. The traditional theme of the young woman at her toilet is one of those intimate subjects that was enthusiastically taken up by the French Impressionists.

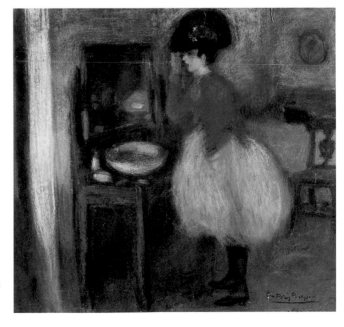

The Paris Circle

"A few days later I met him [Picasso] for the first time, in that little bar the *Lapin Agile*, which at that time, surrounded by dreary, ill-lit plots of land, stood solitary on the heights of Montmartre overlooking the plain. We all sat at the large central table and drank wine, a few painters, poets, literary people. A young man recited verses by Verlaine." This was the account given by the art critic and later Picasso collector Wilhelm Uhde of his first meeting with the artist in Paris in 1905. Initially, because Picasso had not yet learnt to speak French, he sought friends and fellow-artists mainly in the Spanish artists' colony in Montmartre. As a result of his first exhibition in Paris at the

Top:
Georges Braque, 1910
Photograph

Above:
Jean Cocteau, 1926
Photograph

Left:
Guillaume Apollinaire, 1910
Photograph

Long friendships and the intensive exchange of artistic ideas linked Picasso with three people in particular: the poet Guillaume Apollinaire, the painter Georges Braque, and later the writer Jean Cocteau, who persuaded Picasso to work for the theater.

gallery of Ambroise Vollard (who also exhibited Paul Cézanne and had made a name for himself as a discoverer of talented young artists), Picasso attracted the attention of young French intellectuals, notably the poet Max Jacob, a man of his own age who was to become a close friend.

As in the café *Els 4 gats* in Barcelona, a circle of friends and colleagues, La Bande Picasso (The Picasso Gang), soon began to gather almost daily in one of the Montmartre bars for impassioned arguments about art. In terms of theoretical debates, Picasso was drawn far less to fellow painters than to writers and poets, several of whom inspired him in his ceaseless search for a personal style. In the autumn of 1904, for example, Picasso found a kindred spirit in the radical poet Guillaume Apollinaire, who preached the need for a new art liberated from all middle-class values and taboos.

Apollinaire, who wrote reviews for the press, was one of the first to promote Picasso's paintings, and it was through him that in 1907 Picasso met the painter Georges Braque, who soon became his co-worker in the development of Cubism. From 1915 onward, the young avant-garde poet, Jean Cocteau also joined the regular visitors to Picasso's studio and awakened Picasso's interest in theater work. But collectors and art dealers also became interested in this young Spanish artist, among them the rich siblings Leo and Gertrude Stein, at whose hospitable salon Picasso met the painter Henri Matisse.

Portrait of Pedro Manach, 1901
Oil on canvas
100.5 x 67.5 cm
Washington, National Gallery of Art, Chester Dale Collection

The Spanish industrialist Pedro Manach was Picasso's first patron and financial supporter in Paris. He offered the penniless painter a fixed sum of 150 francs a month for his paintings and set up contacts with artists and dealers, above all with the gallery owner Vollard, who organized Picasso's first Paris exhibition. Fifteen pictures had already been sold before the opening, and the exhibition encouraged several critics to take an interest in him.

In this portrait of Manach, Picasso dispensed with all academic rules of painting: the areas of color clash in strong contrast, while the thick black lines enclosing them emphasize the angular outline of the figure.

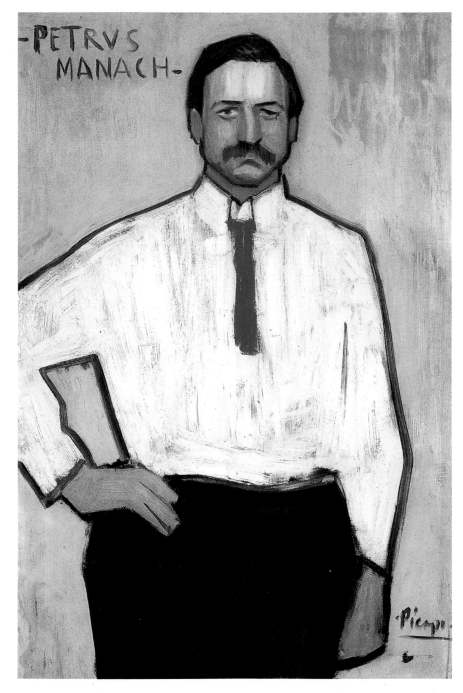

The Blue Period

1901–1904

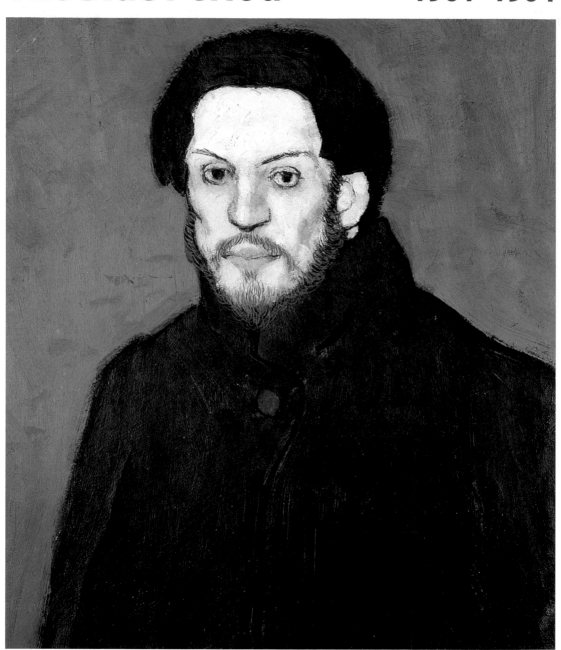

In this early portrait Picasso appears proud, even inviolable; but there is also a deep dejection in his gaze. Painted in the winter of 1901, and showing a pale and emaciated 20-year-old, it communicates the deep melancholy of Picasso's so-called Blue Period. It marks the beginning of a phase of profound artistic and personal change.

Picasso was now creating a pictorial world entirely in shades of blue – a sad and hopeless world of those on the fringe of society, the people who could be seen in the streets and bars of any big city, beggars, the blind, lonely and impoverished women. Picasso used these motifs to create general reflections on life, somber reflections that mirrored his personal situation. Later, one of Picasso's friends observed: "He believed that sadness was favorable to thought, and that sorrow was the basis of life." The pictures of the Blue Period are among the most famous and at the same time most enigmatic of Picasso's works.

Queen Victoria, ca. 1898

Picasso in a Paris café, 1906

1901 Death of Queen Victoria of Great Britain. Theodore Roosevelt becomes US President (until 1909). First wireless transmission across the Atlantic.

1903 Death of Paul Gauguin.

1905 Relativity theory formulated by Albert Einstein. Sigmund Freud: *Three Essays on the Theory of Sexuality*.

1901 Suicide of Picasso's friend Casagemas. Picasso's Blue Period begins.

1902 In April, he has an exhibition at Berthe Weill Gallery in Paris. Further development of his blue monochrome style. Lack of funds force him to produce mainly drawings. Weill exhibits the Blue Period pictures. End of his fixed-term contract with Manach.

1903 In 14 months, paints more than 50 pictures, including *La Vie*.

1904 Picasso settles in Paris, living in his studio in the Bateau-Lavoir. Meets Fernande Olivier.

Opposite:
Self-Portrait with Coat, 1901/02
Oil on canvas, 81 x 60 cm
Paris, Musée Picasso

Right:
Picasso (seated) in his studio on the Boulevard de Clichy (Pedro Manach stands on the left), photograph ca. 1902

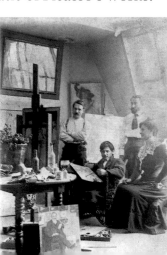

New Beginnings in Art

"The Blue paintings were started in memory of Casagemas," Picasso once admitted. In February 1901 his friend had taken his own life because of an unhappy love affair – a shock Picasso tried to work through in several paintings. The charms of Parisian night life had in any case quickly lost their fascination for him, the initial pleasure of discovery giving way to a desire to withdraw from life. He was now developing an individual style which, in sharp contrast to the then prevailing trends, was initially received with complete incomprehension. Since his pictures sold badly, Picasso's financial situation was also becoming very difficult. At times he was barely able to buy food, let alone canvas and paints. When he was staying in Paris during this period, he lived in small hotels

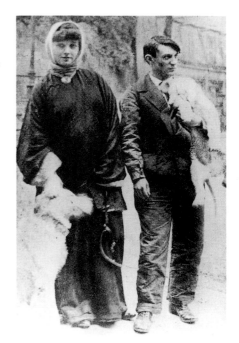

or shared an apartment and studio with a friend to save money. He did not move into a studio of his own in Paris until 1904. He now spent months at a time in Barcelona, and it was there that he produced many of the most important paintings of his Blue Period.

An oppressive mood of sadness weighs on these works. Quite motionless, the figures in the paintings remain pensive, isolated, and lonely. The dominant blue tones give an unreal character to the images, creating a world that seems beyond a specific time and place. Certain figures recur, such as the lonely woman, the mother, the couple in a close embrace. These are not momentary observations, for unlike the quickly dashed-off images of his early

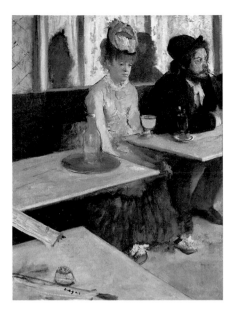

Edgar Degas
In the Café (The Absinthe Drinker),
ca. 1875
Oil on canvas
92 x 68 cm
Paris, Musee d'Orsay

Absinthe, a greenish, bitter drink made from wormwood, was a cheap and popular form of alcohol during the 19th century; today it is outlawed because of its poisonous content. In the late 19th century Degas and Toulouse-Lautrec began to record all the facets of modern city life.

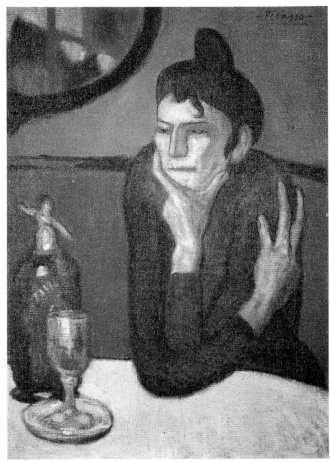

years in Paris, Picasso developed the paintings of the Blue Period carefully: he made many sketches and variations, and did not hesitate to paint over already completed works. When he first exhibited the works from this period, reviewers praised their expressive symbolism, but criticized their unrelieved note of sorrow.

Absinthe Drinker,
1901
Oil on canvas
73 x 54 cm
St. Petersburg, Hermitage

The figure of an absinthe drinker staring numbly ahead of her had been a symbol of the gloomy underside of city nightlife since Degas had painted the subject in 1875.

Picasso set the alcoholic woman in the corner of a café, a glass of absinthe in front of her. In a gesture of self-protection, she hugs herself with her over-long hands and supports her chin in a pose that traditionally symbolized melancholy. To heighten the expressiveness of the painting, Picasso eliminated all inessential details. The closed, block-like forms appear immovable and emphasize the drinker's hopeless situation. In this picture from the beginning of Picasso's Blue Period, the color blue remains restricted to individual objects.

Picasso's Blue

Experience teaches us that individual colors result in particular moods… In order to experience fully the individual significant effects, one must surround one's eye completely with one color, for example placing oneself in a room of one color, or looking through a colored glass … Blue glass shows us objects in a sad light.

Johann Wolfgang von Goethe, 1810

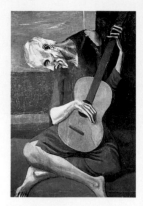

Old Guitar-Player, 1903
Oil on wood
121.3 x 82.5 cm
Chicago, The Art Institute of Chicago

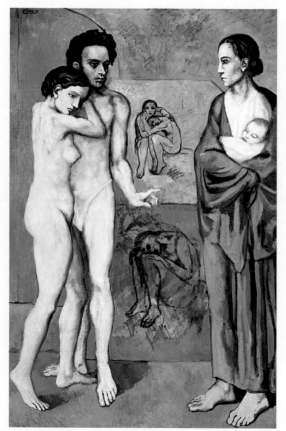

La Vie, 1903
Oil on canvas
196.5 x 128.5 cm
Cleveland, The Cleveland Museum of Art

In their use of a single color, Picasso's blue paintings are unique in art history. Admittedly, since the Middle Ages there had been monochrome paintings in gray, *grisailles*, which often portray saints on the covers or wings of altarpieces. But pictures in which all objects and all figures are steeped in blue were known, if at all, only from photographs, where (before the invention of color film) images in one color were the norm. Picasso's blue paintings form a cohesive group. They were painted within a relatively short period and resemble each other not only in color, but also in theme, mood, and motif. The color blue did not suddenly suffuse Picasso's pictures, nor did it later disappear altogether. At the height of the Blue Period even the faces of the figures have a bluish shimmer. These works have a dreamlike character. The images no longer bear any resemblance to reality; they are, in fact, turned away from reality. Instead of depicting everyday situations, they formulate a poetic message.

We can see this in Picasso's famous painting *La Vie* (Life), a title not in fact given to the work by Picasso himself. A naked couple cling to each other on the left-hand side of the picture; the man is pointing across to the mother in the blue cloak, who is holding her sleeping child in her arms. They look at each other in silence. What does the young man mean by his gesture? In preliminary studies the man had Picasso's own features, and the room was an artist's studio. In the final version the figures are shown in an indefinable space, and the man now resembles Picasso's dead friend, Casagemas. In the background we recognize two pictures with crouching figures, huddled together, shivering and in despair.

An image of the deepest melancholia and tragedy, *La Vie* is not open to a straightforward interpretation. The biographical references are submerged in a somber meditation on life and death, love and motherhood. The most important work of his Blue Period, this large painting is the epitome of this phase in Picasso's development.

The Color Symbolism of the Blue Pictures

The significance of the blue pictures cannot be unlocked in a straightforward manner, and Picasso steadfastly refused to give an explanation for them. The Swiss psychoanalyst Carl Jung interpreted Picasso's blue as an expression of the unconscious, "the blue of night, of moonlight, and of water." In art, the symbolism of the color blue has a long history, from the heavenly blue of the Virgin Mary's cloak during the Middle Ages to the blue flower of longing in 19th-century Romanticism. Blue is the color of the far distance, of the unattainable; it is cool and gently sorrowful. Picasso's blue embraces all these associations.

Picasso's Shades of Blue

In spite of the predominance of a single color, Picasso's blue paintings never appear monotonous. His blue sometimes has the shimmer of a cool turquoise, and then glows warmly with a tinge of purple, and dark blues, dusky to black, alternate with pale blues that have yellowish nuances.

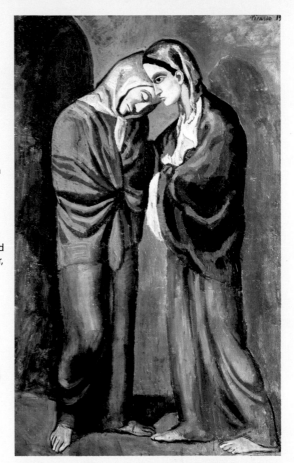

The Encounter (Two Sisters), 1902
Oil on canvas
152 x 100 cm
St. Petersburg, Hermitage

Two women meet and incline their heads toward each other. The closed lines formed by their heads seem to screen them from the outside world. The child carried by one of the women is hardly noticeable, just one little hand extending from the mother's garment.

However modern this picture appears to be in its unreal shades of blue, the subject is totally traditional: Picasso is referring to the Christian motif of the meeting between Mary and Elizabeth, as portrayed in art since the Middle Ages. Stripped of its religious significance, it becomes a general symbol of female closeness and compassion.

The Rose Period 1905–1906

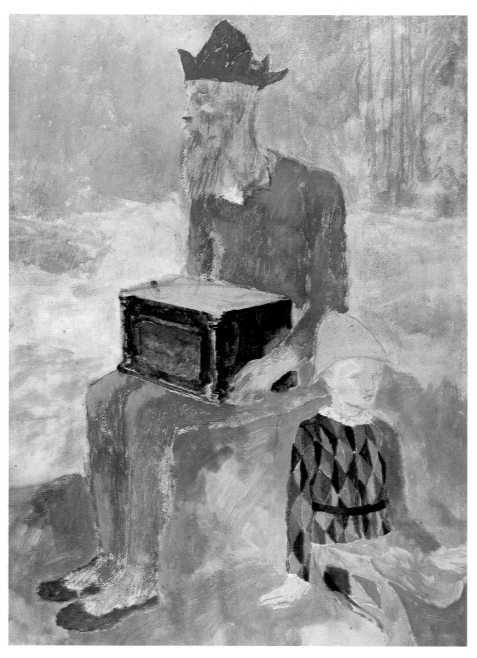

From 1904 onward there were positive changes in Picasso's personal life. In Fernande Olivier he had found a mistress and companion willing to share his impoverished existence in a small studio in the Bateau-Lavoir. Through her a new warmth and cheerfulness entered his life and his work. New colors gradually began to appear in his paintings – a gentle rose pink, warm red tones, and other light colors.

In addition, Picasso was now enthusiastically developing a new theme, which was to occupy him almost exclusively for some time – the world of traveling entertainers and acrobats. And for the first time he was also creating sculptural works, which he modeled in wax or clay and then cast in bronze. The pictures of the so-called Rose Period sold well, and consequently his financial situation soon eased. He spent the summer in Spain with Fernande, where, in the seclusion of the Catalonian mountain village of Gosol, he painted nudes of an almost classical beauty in soft, earthy colors.

Mutineers on the Potemkin

1905 The Russian Revolution is only partially successful: the Tsar gives Russia a constitutional structure. The Moroccan crisis begins.

1906 Death of Paul Cézanne.

Picasso in his studio, 1907

1905 Picasso's Rose Period begins. First sculptures, and the etchings *Tightrope Walkers*.

1906 Picasso meets Henri Matisse, André Derain, and the art dealer Kahnweiler. Vollard buys most of his Rose Period paintings and thus enables Picasso to lead a life free of financial worries.

Opposite:
Barrel-Organ Player and Harlequin, 1905
Tempera on cardboard
100.5 x 70.5 cm
Zurich, Kunsthaus

Right:
Fool, 1905
Bronze
h. 41.5 x w. 37 x d. 22.8 cm
Paris, Musée Picasso

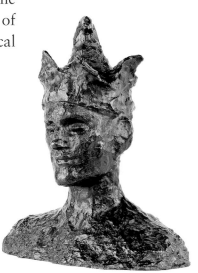

Bohemian Life and Traveling People

Life in the studio-house Bateau-Lavoir was far from comfortable. Within the multi-levels of this ramshackle wooden building, which was situated on a steep slope on the hill of Montmartre, ten studios were crowded together with improvised apartments and no running water. In summer it was fiercely hot, in the winter ice-cold and drafty. Impoverished artists of the most varied origins lived and worked here, including Georges Braque, Juan Gris, Amedeo Modigliani, and the poet Max Jacob. It was an unique world, where money might be in short supply, but imagination, wit, and absurd ideas were never lacking.

In her memoirs, Fernande Olivier relates how at that time Picasso and his friends used to attend the performances of the Cirque Medrano several times a week. They were enchanted by the wit and grace of the harlequins and acrobats, and these traveling people now played the major role in Picasso's paintings, taking over from the beggars and poor people of the Blue Period. But he did not paint them as brilliant figures on a stage; he depicted their everyday life behind the scenes, sitting lost in thought during moments of rest, or in uncertain situations. Picasso's entertainers exude a subdued melancholy, but it is no longer the unrelieved despair seen in the Blue Period. Oppressive

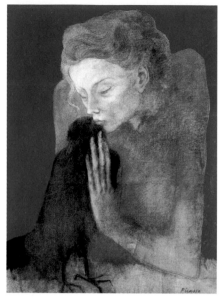

Dear Sir, the creator of this Harlequin is already quite well known… You would do well to remember his name: Picasso.

Eugène Marsan

Woman with Crow,
1904
Charcoal, pastel, and watercolor on paper
64.8 x 49.5 cm
Toledo Museum of Art

In this early painting of Picasso's Rose Period a woman of delicate beauty is depicted caressing her pet crow. In the poetry of the Middle Ages a tame falcon was a symbol of the sweetheart longed for by a maiden. Picasso captures the intimate closeness of the woman and the bird in a closed outline that embraces them both. He has delineated the woman's face, which is set in front of a brilliant blue background, with the most delicate brush strokes that have the precision of an Old Master.

Family of Traveling Entertainers, 1905
Oil on canvas
212.8 x 229.6 cm
Washington, National Gallery of Art, Chester Dale Collection

This large painting, a major work of Picasso's Rose Period, was the result of many preliminary studies. Originally a horse race formed the background to the family of entertainers, who are shown standing together in a motionless group. The seated woman, front right, was added only at the final stage. Disturbing features such as the missing right foot of the fat clown in the red costume, as well as the figures' vacant expressions, mean that they remain somewhat intangible, despite their clearly outlined forms. In a poem, the German writer Rainer Maria Rilke tried to capture the enigmatic magic of this picture: "But who are they, tell me, these traveling people, these who are even a little more fugitive than we ourselves...?"

Opposite:
Picasso with friends at a café in Montparnasse

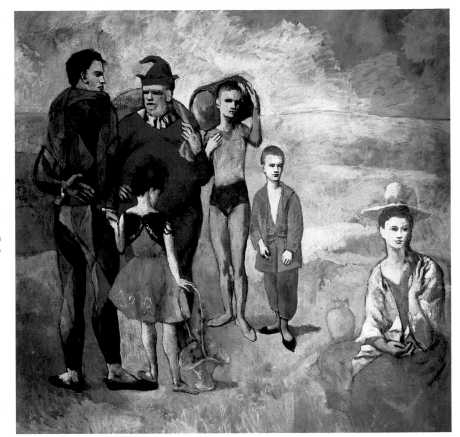

loneliness has given way to family life, and the clowns and acrobats, for all their vulnerability and helplessness, radiate an inner closeness. With tender gestures and touches, they turn to and protect each other. Picasso's repertoire of types is clearly defined here: apart from the adult, brightly dressed Harlequin, and an older, fat clown in his red costume, there are children, half-grown boys and young girls, and sometimes animals, too.

It is quite a new, tender, and vulnerable beauty that is displayed by the pictures of the Rose Period. Picasso was now varying the expressive potential of line: delicately curved outlines of subtle beauty give a precise form to the figures and lend them a previously unknown grace. Apart from the subtle drawing of the outlines, which was now usually executed in a dark color, the physical character of the figures also took on new meaning during the Rose Period, with the bodies of the entertainers becoming more evident under their close-fitting leotards.

Picasso's Pink

Harlequins and clowns are ever-present in the paintings of Picasso's Rose Period. Like an acrobat of painting, in these pictures Picasso plays confidently with the possibilities of creating a balance between color and form. The picture *Acrobat and Young Harlequin* (below) is a good example of such a well-balanced composition. Two entertainers are seated side by side, a young man and a small boy. The boy gazes at the man, who is lost in thought, as if staring at his own, aging mirror-image. The two halves of the composition are also mirror-like in their formal correspondence. Two colors dominate the entire picture: a pervasive pink, earthy and warm, and a cool blue that acts as a counterbalance. The picture is built up almost entirely of geometric forms, of straight lines and right angles. The gaunt figures of the two athletes are stylized in such a way that the upper halves of their bodies and their arms almost form a square. Their pale faces are framed by light-colored ruff-like collars that are the only circular shapes in the picture. In spite of the angular shapes, the effect of the picture is one of great delicacy.

The Color Palette of the Rose Period

In his Rose Period, Picasso often painted with great subtlety. He frequently used earth-colored, brownish pink, and ochre tones as almost monochromatic, but delicately varied backgrounds. The pink is finely shaded and modeled to enhance the body shapes; the rounding of the limbs can be seen, and muscle and bone structure are indicated. All this is particularly true of the nudes in the later Rose Period pictures, such as *Two Brothers* (top).

Picasso's palette in his so-called Rose Period included not only pinks, but also colors such as matte ivory white, delicate green and blue, and sandy yellow. Brilliant, lurid colors are not to be found, but rather shades that are mainly light, almost translucent, always carefully attuned to each other.

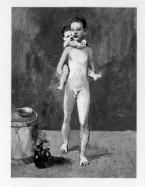

Two Brothers, 1906
Gouache on cardboard
80 x 59 cm
Paris, Musée Picasso

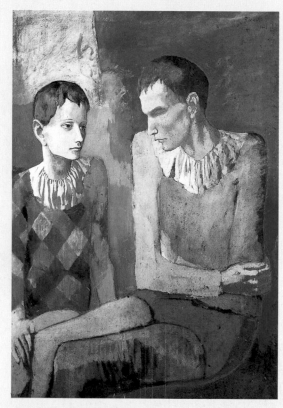

Acrobat and Young Harlequin, 1905
Gouache on cardboard
105 x 76 cm
Brussels, private collection

**Family of Acrobats
with Ape**, 1905
Gouache, watercolor, pastel,
and India ink on cardboard
104 x 75 cm
Göteborg, Museum of Art

Despite its multi-colored
appearance, this picture of a
family of acrobats does not
appear garish; in fact the
well-balanced color
composition creates a
picture of great harmony.
Picasso chose not pure,
brilliant tones but broken,
shimmering colors. The
ochre underpainting, which
remains visible beneath the
lightly applied paint, helps
to create a warm and
intimate mood. The green
and blue of the background
and the yellow of the
clown's hat are repeated in
the mother's dress. The
lightest accents of color lead
the eye to the small child.
This is also the center on
which the attention of the
figures is concentrated.

Like many pictures of
Picasso's Rose Period, this
painting is a carefully
composed structure of
forms, lines, and gestures.
The family conveys a feeling
of intimate security, and yet
there is, once again, a
disturbing element: Picasso
adds to the group of human
figures an ape, clearly a tame
one, which, in its attitude
and gaze, seems only to
strengthen the harmony of
the image. Nevertheless, it
adds a curious air of
unreality to the scene, and
suggests a concealed and
private symbolism.

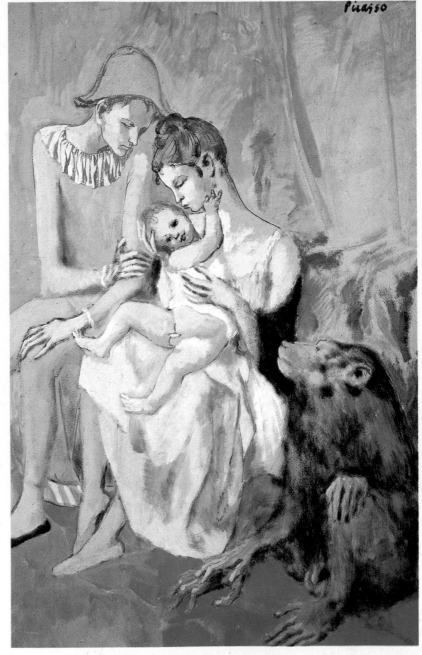

Cubism

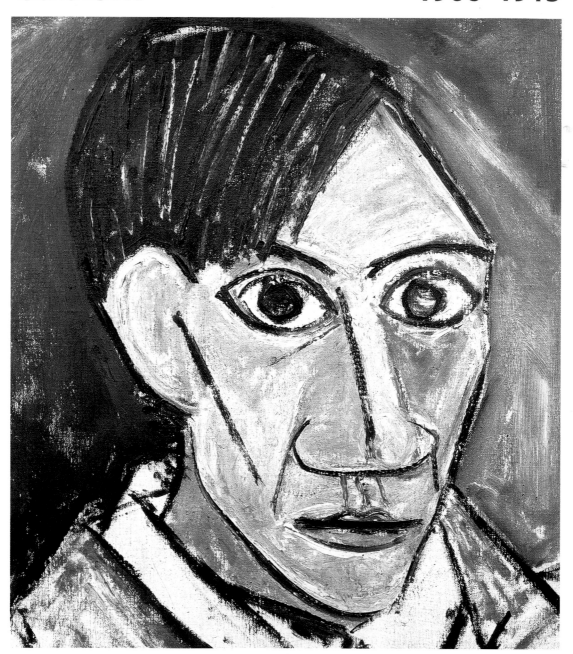

Cubism, which represented a complete break with artistic tradition, was perhaps the major achievement of 20th-century art. After Picasso had created radically new forms with his shocking painting *Les Demoiselles d'Avignon*, Cubism became an adventure that he and Georges Braque undertook together. In a close artistic collaboration they developed a completely new language of forms. Cubism freed art from the mere depiction of reality; it fragmented the visible world into the smallest particles, and then organized them anew. Only the motifs themselves – landscapes, portraits, and still lifes – remained from the traditional repertoire of art.

Since Picasso's work was now internationally known through exhibitions, the impact of Cubism soon became widespread, and it had a direct impact on such movements as Futurism in Italy, Constructivism in Russia, and De Stijl in Holland.

War begins 1914

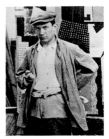

Picasso, ca. 1915

1907 The new Kahnweiler Gallery opens. Cézanne retrospective opens in Paris.

1908 Braque exhibits the first Cubist pictures from L'Estaque at the Kahnweiler Gallery.

1912 Sinking of the *Titanic*.

1913 The Expressionist artists' group Der Blaue Reiter (Blue Rider) is founded. The French artist Marcel Duchamp uses 'ready mades.'

1914 World War I begins. Braque and Derain are called up.

1907 Picasso sees African sculptures in the Ethnological Museum in Paris. Paints *Les Demoiselles d'Avignon*. Meets Georges Braque.

1909 Productive period in Horta de Ebro: Cubist landscapes.

1910 Picasso's first exhibitions in Germany and England.

1911 Picasso's first exhibition in New York. Begins affair with Eva Gouel.

1912 Exclusive contract with the gallery owner Daniel-Henry Kahnweiler. Breaks up with Fernande. Moves to the Boulevard Raspail, Montparnasse.

1913 Death of Picasso's father. Beginning of Synthetic Cubism.

1915 Death of Eva Gouel in December.

Opposite:
Self-Portrait, 1907
Oil on canvas, 50 x 46 cm
Prague, Narodni Gallery

Right:
Guitar, 1912
Cardboard, paper, canvas, string, pencil
Paris, Musée Picasso

The Cubist Revolution

The adventure of Cubism can be understood as an experiment in which artists tried to free themselves from the mere representation of nature, though without going so far as to create wholly abstract works. A picture was no longer primarily a depiction of the world, but an object in itself.

The transformation of a subject into an image, utterly changed but having a visual logic of its own, became the point and purpose of a painting. But painting without a subject never interested Picasso; even though he did distance himself from the straightforward depiction of the visible world, the subject itself, or a fragment of it, is always recognizable. In 1906, under the influences of old Spanish sculpture, characterized by its sharp, angular forms, and of Paul Cézanne, Picasso had begun to paint female nudes in block-like forms. Only a year later, the rejection of nature as a model reached its high point in the revolutionary painting *Les Demoiselles d'Avignon* (page 37), a work that deeply shocked his contemporaries. The paintings that followed were less aggressive and provocative, but no less revolutionary.

From 1907 onward, Picasso found in Georges Braque a close and congenial comrade-in-arms in the development of Cubism. While Braque's reaction to *Les Demoiselles*, in the

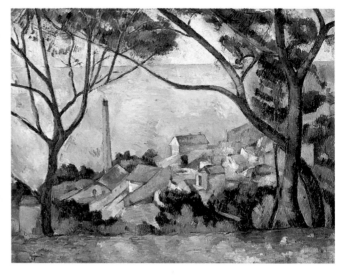

Paul Cézanne
The Sea at L'Estaque,
1878–1879
Oil on canvas
73 x 92 cm
Paris, Musée d'Orsay

By freeing art from the traditional task of merely representing the world, Cézanne tried to reduce the multiplicity of forms in nature to a few basic geometric elements. In 1905 and 1907, paintings by Cézanne were to be seen in large exhibitions in Paris and exercised a strong influence on Picasso. "Do I know Cézanne! He was my one and only master," Picasso declared in 1943.

summer of 1908, was a series of geometric landscape paintings, Picasso was independently achieving amazingly similar results. For both artists, houses, trees, and the other elements of landscape became frozen into angular geometric masses in which the parts were arranged layer upon layer to create an opened-out, multi-faceted image. There was no hint of traditional perspective. Cézanne had demanded that natural images should be formed from "spheres, cones, and cylinders"; Picasso and Braque effectively overturned Cézanne's principle by pushing it to its logical conclusion. When Braque exhibited the first of these paintings, a critic picked up an observation by Henri Matisse that the pictures consisted of nothing but little cubes, and soon "Cubism" was an established concept.

The development of Cubism can be divided into three distinct phases.

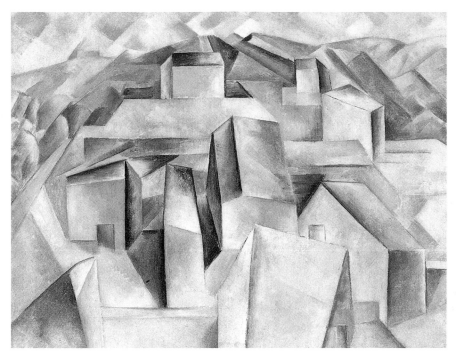

**Houses on a Hill
(Horta de Ebro)**, 1909
Oil on canvas
65 x 81 cm
New York, The
Museum of Modern
Art, Nelson A.
Rockefeller Bequest

In the summer of
1909, during a stay in
the Spanish mountain
village of Horta de
Ebro, Picasso painted
a series of landscapes.
He simplified houses
and landscape forms,
as in this picture, to a
structure of
geometric patterns.
The forms are piled
up, one above the
other, like large
crystals or building
bricks. Here Picasso
abandons the use of
traditional central
perspective and
creates a new form of
three-dimensionality.
The areas of light and
shade in the picture
do not reproduce the
natural lighting, they
model each form
individually.

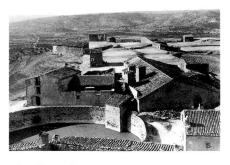

**The village of Horta
de Ebro**, 1909
Photograph by
Picasso

Initially, works were painted under
the direct influence of Cézanne.
From 1909 came Analytical Cubism:
here Picasso and Braque fragmented
the subjects into ever smaller parti-
cles until they were hardly recogniz-
able. Then, from 1912, Synthetic
Cubism emerged. Larger, more cohe-
sive abstract forms and areas of
color were combined, often creating
forms that clearly referred to such
familiar items as a guitar or a bottle.

For Picasso, the Cubist period
meant that he rapidly became well
known, his pictures sold at ever
higher prices, and in 1909 he was
able to move into a larger, more
comfortable studio apartment on the
Boulevard de Clichy.

Les Demoiselles d'Avignon

When Picasso's friends saw this picture for the first time in 1907 their reaction was one of shock and incomprehension; it was not exhibited until 1916. Today it is regarded as a key work in modern art.

Five over-life-size naked women stare at the observer and display their bodies in a shamelessly provocative manner. However, it was not their evident sensuality alone that was shocking, but, above all, the manner of their depiction. Picasso, who was an excellent draftsman, rejected the skillful depiction of nature as an aim and instead paraded its primitive 'opposite': all his figures are angular and crude, as though hewn out with an ax. Most strikingly,

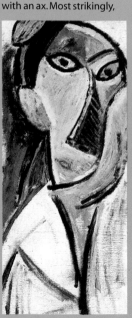

Study for *Les Demoiselles d'Avignon*, 1907
Oil on canvas
96 x 33 cm
Basel, Öffentliche Kunstsammlung, Kunstmuseum

Right:
Study for *Les Demoiselles d'Avignon*, 1907
Pencil and pastel on paper
47.6 x 63.5 cm
Basel, Öffentliche Kunstsammlung, Kupferstichkabinett

Here the brothel scenes that was the original subject of the picture can still be detected: the women grouped round a table offer themselves to the visitor entering on the left.

the faces of the two women at the right-hand edge of the painting are distorted; their mask-like features seem hardly human.

From 1906 Picasso, stimulated by, among other things the great Gauguin retrospective and visits to the Ethnological Museum in Paris, had been coming to grips with so-called 'primitive art.' African wooden sculptures, with their simplified forms and direct symbolism, fascinated him so much that he acquired several African carvings. And, as so often in his life, by means of a reworking of something already in existence, Picasso found his way to a new, completely individual form

of artistic expression. He worked on this painting for three-quarters of a year, and more than 800 sketches and studies have been preserved.

Originally, the painting was conceived as a brothel scene. The title "The young ladies of Avignon," refers to a brothel in the Calle d'Avignon in Barcelona. In the final version, however, all traces of narrative have disappeared. All harmony is destroyed, and space is fragmented into geometric facets. Fundamentally, the picture deals with two classical genres (the nude and the still life), but it consciously frees itself from all traditional rules of painting. Above all this work represents the struggle for a radically new language of painting, and in this it has lost none of its explosive power, even today.

Les Demoiselles d'Avignon, 1907
Oil on canvas
243.9 x 233.7 cm
New York, The Museum of Modern Art

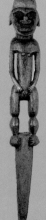

Female statue from New Caledonia (from the Pablo Picasso Collection)

With its highly simplified and expressive forms, the tribal art of Africa and the South Seas fascinated Picasso and many other modern artists.

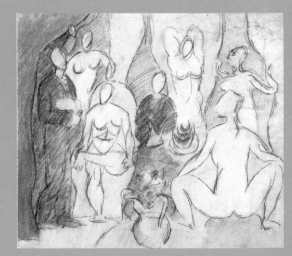

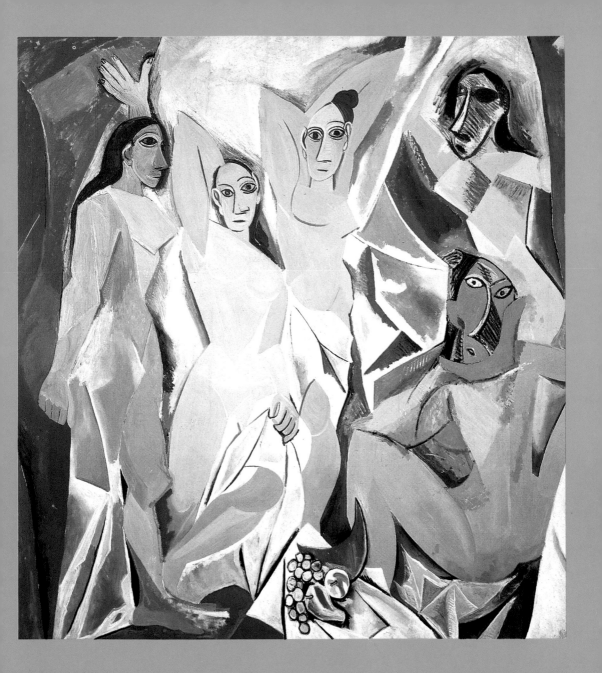

Guitar and Bass Bottle, 1913
Charcoal, nails, pieces of wood, paper
89.5 x 80 x 14 cm
Paris, Musée Picasso

In this assemblage, Picasso in effect made the two-dimensional collage three-dimensional. In the manner of a relief, various pieces of wood with newspaper clippings, are brought together to form a work that projects into space. As a result of both the painting and the combination of parts, the form of a guitar and a bottle emerge.

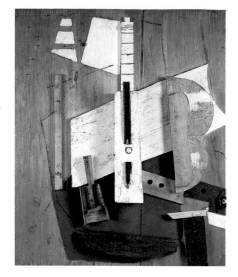

Cubism and Collage

Picasso's experimentation with form led him to the development of a new field of artistic work: collage and assemblage.

With his untiring curiosity, Picasso always found sources of inspiration in the world around him, and at this time began to incorporate elements of physical reality into his art: newspaper clippings, pieces of wood, cardboard, metal, parts of woven cane chairs, or playing cards – all kinds of materials and objects were transformed into images in Picasso's hands, as though they had never served any other function. This approach not only created new ideas for pictures, it also created pictures that were entirely novel in form. For, with collage, the world is no longer merely depicted but actually becomes a physical part of the artwork.

Picasso pushed this idea even further by developing the assemblage technique, extending the surface of the picture through the addition of three-dimensional objects. Now his works were no longer flat panels, but sculptural objects which, literally emerging from the picture frame, represented a completely new kind of artwork. Collage and assemblage have remained important techniques up to the present day; applied in the most varied ways, they have been further developed by many artists who are in search of artistic authenticity and a language of images appropriate to modern life.

Picasso took artistic liberties that had previously been unimaginable. In two-dimensional works he fragmented forms and altered their appearance; in his three-dimensional works he went even further, unceremoniously redefining the reality of found objects – a sheet from a newspaper was turned into a violin, a cardboard box mutated into a guitar, and an abandoned wooden panel found new life as an element in a still life. Now, as he was often to do later, Picasso continually switched back and forth between painting and sculpture. But with all these works he never lost touch with a recognizable reality. In his many still lifes and figure paintings he included references to his visits to restaurants and cafés in Paris, exhibited musical instruments and other objects from his studio, and depicted his friends and loved ones.

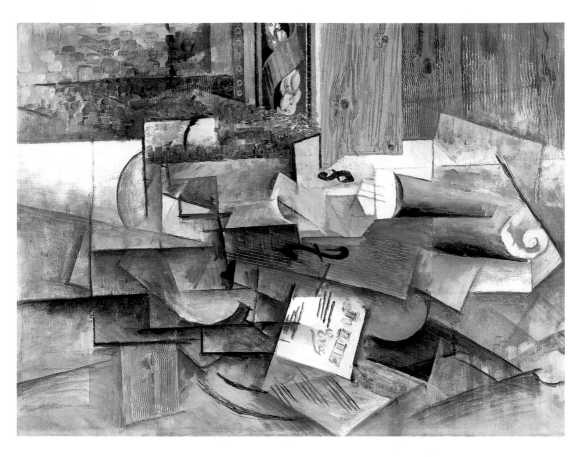

Opposite:
Eva Gouel (Marcelle Humbert), 1912
Photograph

"… I love her very much, and I will write her name on my pictures," Picasso said in 1912. He never painted a portrait of her – Eva Gouel died of tuberculosis as early as 1915 – but there are many concealed references to "Ma Jolie", my pretty one, as he called her.

Above:
Violin 'Jolie Eva',
1912
Oil on canvas
60 x 81 cm
Stuttgart,
Staatsgalerie

Playing with the rounded forms of the violin and the woman's body, Picasso makes use of wood-grain and a painted sheet of paper bearing the title "'Jolie Eva" to create a harmonious composition.

His "objects" are his love affairs; he has never painted an object with which he did not have an emotional relationship.

Daniel-Henry Kahnweiler

The Technique of Cubism

He despises organic forms, and reduces everything – landscapes, figures, and houses – to geometric patterns, to cubes.

Louis Vauxelles on Braques' Cubist work, 1908

With *Les Demoiselles d'Avignon* of 1907, Picasso had ushered in a revolution in painting. And during the various phases of Cubism he continued his exploration of images that came close to, but never quite reached, total abstraction. As early as the spectacular *Les Demoiselles*, Picasso's search for representational forms that did not conform to traditional painting was very evident. As Gertrude Stein observed, Picasso was "the only painter who saw the 20th century with his own eyes and saw its reality."

By the beginning of the 20th century, many traditional certainties were being questioned, notably by the rapid development of

scientific knowledge, and also by the West's growing awareness of non-European cultures, made possible by Europe's many colonies. Picasso's portrayal of the strange-looking women in *Les Demoiselles* can be seen as a reflection of this uncertainty. He analyzed the depiction of reality in art by means of its basic elements, form and color. With reference to Cézanne's advice that "one should treat nature in terms of cylinders, spheres, and cones," he fractured a subject into geometrical components that he then reassembled to form an image – and by doing so brought an independent reality into being.

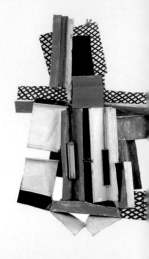

Violin, 1915
Painted metal and iron wire
100.1 x 63.7 x 18 cm
Paris, Musée Picasso

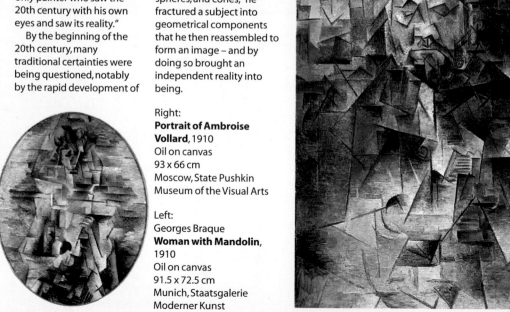

Right:
Portrait of Ambroise Vollard, 1910
Oil on canvas
93 x 66 cm
Moscow, State Pushkin Museum of the Visual Arts

Left:
Georges Braque
Woman with Mandolin, 1910
Oil on canvas
91.5 x 72.5 cm
Munich, Staatsgalerie Moderner Kunst

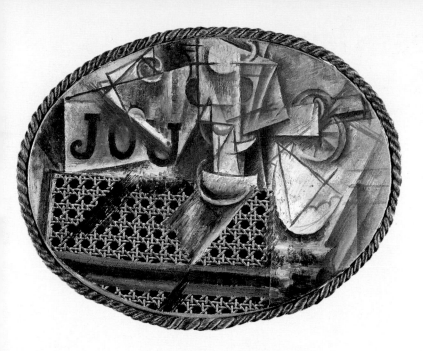

contradiction here, for it was one of the aims of Cubist painting to achieve multiple views of an image; that is, to show an object from several angles at the same time, which is otherwise only possible in three-dimensional art.

Freed from the need to depict the world, from 1912 Picasso and Braque created collages and assemblages that combined various materials, including prosaic everyday objects, and painted areas.

The idea of Synthetic Cubism also found its expression in sculpture. Here the observer's attention is directed to the components of reality, while the presentation of three-dimensionality is achieved by breaking an image into facets, as in Cubist painting, and also by creating new spatial relationships. With works such as the *Violin* of 1915 (opposite, top right), Picasso had reached the final point of these experiments, though he was to return repeatedly to the question of the relationship between representation and reality.

Braque and Picasso developed Analytical Cubism in close collaboration. Broken into countless fragments, the subject of a portrait or still life, now a crystalline, multi-faceted image, is recognizable only from a distance. The mainly dark colors are independent of the subject, and yet they still help to convey varying moods and contribute to the characterization of the motif.

A comparison of the portrait of the art dealer Vollard (opposite) with the bronze *Woman's Head* (right) – a portrait of Picasso's companion Fernande Olivier – shows that this dissolution of forms could easily be transferred from two dimensions to three. Admittedly there is a

Still Life with Woven Cane, 1912
Oil on waxed cloth and canvas, with string frame
29 x 37 cm
Paris, Musée Picasso

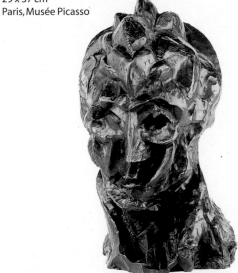

Woman's Head, 1909
Bronze
h. 40.5 x w. 23 x d. 26 cm
Paris, Musée Picasso

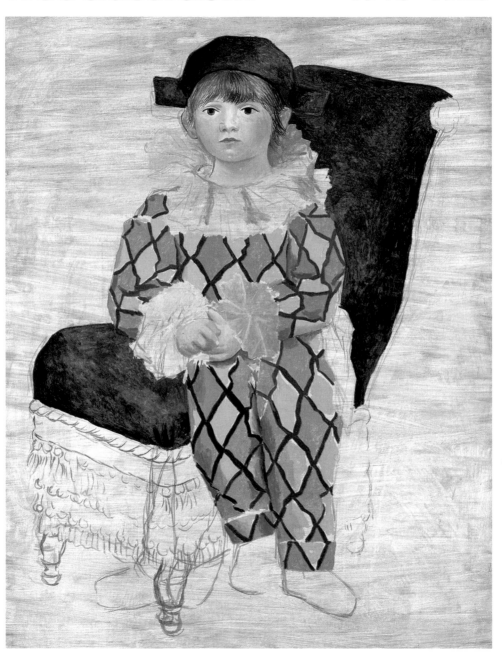

Both artistically and personally, Picasso's life during the period 1916–1925 was marked by decisive changes. In search of new means of expression, he now directly confronted his major predecessors in art history. Lines and edges now became important, and mass and physical forms were interpreted in an entirely new way. In complete contrast to the fragmented Cubist works he had only recently been creating, Picasso was now painting balanced, often monumental works.

Introduced to the world of dance and drama by his friend Apollinaire, Picasso designed stage décor and costumes and traveled to Rome to work on a new ballet. There he met the Russian ballet dancer Olga Koklova, whom he married in 1918 in Paris. With the birth of their son Paul in 1921, Picasso became a family man for the first time, at the age of 40.

Lenin addresses workers

1917 Russian Revolution.

1918 End of World War I. Death of Apollinaire.

1919 Peace Conference at Versailles. Weimar Republic proclaimed.

1922 Mussolini becomes prime minister of Italy.

1925 Adolf Hitler publishes *Mein Kampf* (adopted as National Socialist program).

Picasso in Paris, ca. 1916

1917 Picasso travels to Rome with Cocteau. Meets Igor Stravinsky and the Russian dancer Olga Koklova. Travels in pursuit of her. Olga stays with him.

1918 Through the ballet world Picasso makes contact with high society, and his marriage to Olga changes his lifestyle. Paul Rosenberg becomes his new dealer.

1919 Meets Joan Miró and buys one of his pictures.

1920 Designs for the Stravinsky ballet *Pulcinella*. Kahnweiler returns from exile.

1921 Birth of his son Paul (Paolo).

Opposite:
Paul as Harlequin, 1924
Oil on canvas
130 x 97.5 cm
Paris, Musée Picasso

Right:
Olga, Sewing, 1921
Drawing
Paris, Musée Picasso

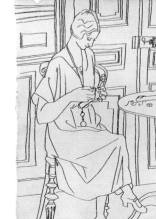

Experiments in the Theater

In 1916, through the poet Jean Cocteau, Picasso met Sergei Diaghilev and the Ballets Russes company he had founded. He followed the group to Rome in 1917, and within a few weeks he had produced designs for the costumes and décor of a new ballet, *Parade*.

In close cooperation with Cocteau, the Ballets Russes, and the French composer Eric Satie, Picasso created a sensational collection of designs, and was thus decisively involved in the creation of this ground-breaking ballet. When the premiere took place in Paris in 1917, the audience was incensed. They protested loudly during the performance and this finally culminated in a riot. "It was a very unconventional ballet," recalled the Russian writer Ilya Ehrenburg, "a fairground booth with acrobats, jugglers, clowns, and a trained horse. The ballet demonstrated the apathetic movements of an automaton – it was the first satire on what was later called 'Americanism'."

Everything in this piece was new and unusual: traditional ballet theater was replaced by elements from the circus, technical apparatus from the world of industry turned up on the stage, and the production contained both acoustic and visual impressions of big city life – typewriters rattled, loudspeakers crackled, and Picasso's striking décor crowned everything. The alternation between different styles, typical of Picasso's work at this time, also influenced his theatrical designs: a Cubist fragmentation of shapes was adopted above all for the costumes, requiring that the dancers had to don complicated constructions which gave the impression of being elaborate statues. On the other hand, Picasso designed the stage curtain using the manner and language of forms reminiscent of his Rose Period, with a spatially composed image of quiet, subdued colors, and motifs that conjured up the world of the circus before the curtain goes up – a world of horses, harlequins, artistes, and musicians.

Picasso's stylistic versatility clearly met in full the requirements of this extraordinary production – a production that sought to combine the most varied elements of modern reality in an artistic unity.

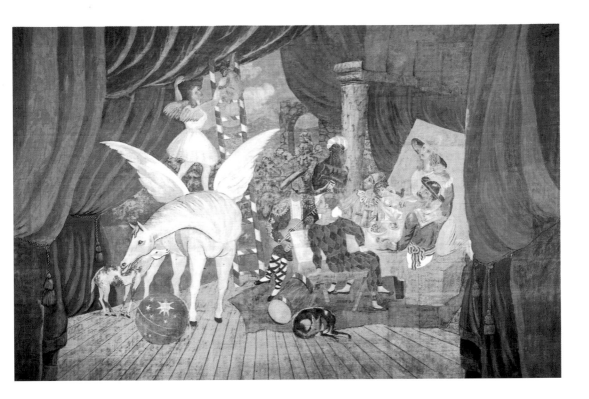

Stage Curtain for
Parade, 1917
Tempera on cloth
1,060 x 1,725 cm
Paris, Musée National
d'Art Moderne, Centre
Georges Pompidou

As in the paintings of
the Rose Period, in his
stage curtain design
Picasso refers to the
world of the
harlequins,
entertainers, and
dancers, depicting
them in muted colors.
 A diverse group is
seated around a table
watching a female
acrobat with a small
monkey, which is
performing a trick.

The young woman
is standing on a
winged white horse,
which is turning
toward its foal. It is a
stage scene that is
being shown; on
either side the red
curtain is opening for
the performance,
which is set against a
southern landscape
with ruins – the theme
of the curtain design
can clearly be traced
back to Picasso's
impressions of his
journey to Italy.

Horse costume in
Parade, 1917

What Picasso achieved was wonderful, and I can hardly
say what made me most enthusiastic, the colors, the
spatial design, or the astonishing theatrical instinct of
this exceptional artist.

Igor Stravinsky

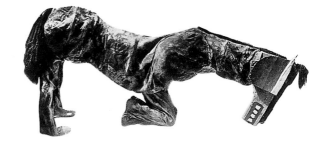

Photograph and Likeness

When Picasso accompanied the Ballets Russes to Italy in 1917, he not only became fascinated by the historic sites and the life of Italian country folk – he also fell passionately in love with the Russian ballerina Olga Koklova. They were married a year later in Paris according to the rites of the Russian Orthodox Church. Picasso's bohemian life was now over, particularly as this marriage introduced him to the higher circles of society.

It was at this time that photography first entered Picasso's work. He was already a keen photographer, but his interest in this medium now became reflected in his work. If we take into account that at this time there was as yet no color photography, and that the essence of black-and-white photography consists in presenting a natural likeness in a gradation of gray tones, it becomes apparent how logical, and at the same time how illuminating, Picasso's artistic application of this medium to painting was. He now frequently worked directly from photographs, reduced the soft light-and-dark effects of photography to harsh contrasts, and finally enclosed his subjects within simple outlines. By means of this simplification he now focused on the essential component of a picture: the subject. At the same time, by adopting the apparently 'realistic' view of things as seen through the lens of a camera, he was able to create images that quite deliberately draw attention to the distortions of perspective common in a photograph. For Picasso, even a photograph was not a straightforward representation of the world.

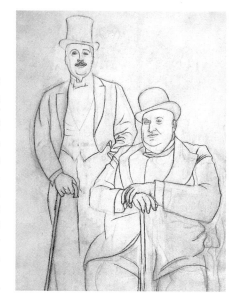

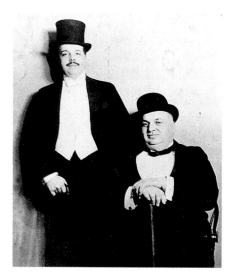

Portrait of Sergei Diaghilev and Alfred Seligsberg, 1919
Charcoal and pencil on paper
63.5 x 49.6 cm
Paris, Musée Picasso

Picasso created this drawing of the two ballet impresarios directly from the photograph shown below. It is a simple outline drawing, which shows the contours of the figures, but hardly suggests mass or physicality. It is a drawing characterized by sobriety and the search for objectivity. All the more striking, therefore, is the fact that the lower half of the body of the right-hand figure appears too large in relation to the upper half. This is explained by a distortion of perspective in the photograph, the result of taking the photograph from a certain angle. Picasso stresses his deliberate misdrawing with a directness that borders on a criticism of photography. In exposing the camera image as a 'distortion' of the subject, he challenges the supposed objectivity of the photographic eye – yet at the same time, he concedes to photography the qualities of an independent art form.

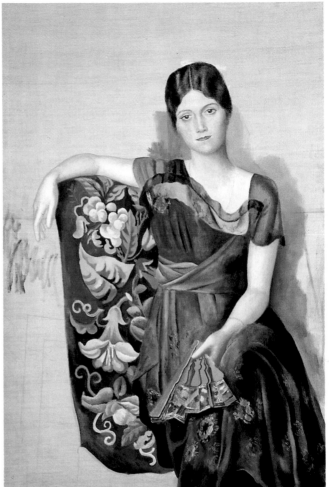

Olga Koklova in the studio, ca. 1917
Photograph by Picasso

This photograph of his first wife served as a model for Picasso's painting of her (right). In this incomplete painting, figure and chair are enlarged in relation to the format of the photograph. Despite the glowing colors, the picture has a curious air of artificiality; the figure looks isolated in the empty space of the picture. The young Russian woman seems more 'foreign' than in the photograph; she has become one with the placid décor of her surroundings. The painted portrait has become a portrait of the soul.

The significance of Picasso's confrontation with photography for his later work lies in his examination of line and his exploitation of 'natural distortions.' These distortions of mass and scale in a photograph were to become crucial for Picasso's later work. His works from this period have a strange quality: in spite of all the delicacy and beauty that these images possess, they also have a cold and impersonal effect, the figures usually staring out from the picture rigidly. Never again would Picasso's figures appear as cool and unemotional as during this phase.

Portrait of Olga in a Chair, 1917
Oil on canvas
130 x 88.8 cm
Paris, Musée Picasso

Neoclassical Works

Picasso's journey to Italy in 1917 also introduced him to the sites of classical antiquity – especially Rome, Naples, and the buried city of Pompeii. The impressions he gained there were reflected in pictures of massive nudes and people wearing flowing garments reminiscent of Roman robes, figures that fill the entire space of the picture with a measured calm and solemnity. Like mighty sculptures, they sit or stand alone or in small groups separated from time and place.

In addition, Picasso drew and painted nudes that are, above all, defined by their outlines, a development that was the result of his preoccupation with the French painter Ingres (1780–1867), whose figures are also enclosed in clear contours (page 62).

Throughout his career Picasso repeatedly returned to the models of art history; during his Neoclassical period he was mainly inspired by classical figure compositions, the monumental figures of the high Renaissance (particularly those of Michelangelo), and the paintings of the French artist Nicolas Poussin (1593/4–1665), whose themes were derived from classical antiquity. Picasso studied them according to his own distinctive interests, which lay in the monumentality of the sculptures of antiquity and the Renaissance. He was fascinated in particular by their powerful forms and by the heavy folds of their garments.

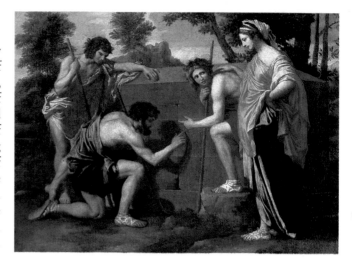

Nicolas Poussin
Et in Arcadia ego (Arcadian Shepherds) (detail), 1650–1655
Oil on canvas
85 x 121 cm
Paris, Louvre

Picasso's figures during his Neoclassical phase look like roughly hewn statues. A comparison with Poussin shows not only the source of his inspiration, but also the independence of Picasso's creative methods. Picasso's concern is with the sculptural attitude of the figures, which is emphasized by heavy fabrics and the fullness of its folds.

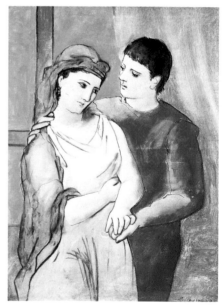

Lovers, 1923
Oil on canvas
130.2 x 97.2 cm
Washington, National Gallery of Art, Chester Dale Collection

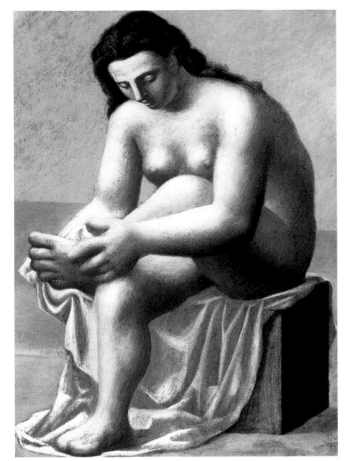

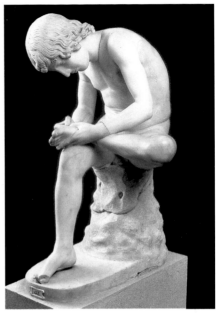

Boy Pulling Out a Thorn,
Early Roman, imperial era,
Marble, h. 82 cm
Berlin,
Pergamonmuseum

But in contrast to these classical models, Picasso's Neoclassical works reject the traditional method of representing the ideal, for his figures are not athletically beautiful; they have gigantic bodies and often disproportionately large hands and feet.

Seated Nude Drying her Foot, 1921
Pastel on paper
66 x 50.8 cm
Berlin, Sammlung Berggruen

The classical motif of a boy pulling out a thorn has often been cited by artists up to the 20th century, and Picasso refers unequivocally to this model (above right) in his painting.

He has, however, changed the subject matter: the woman is drying her foot. The exaggerated size of her hands and feet, as well as the economical execution of detail, lends a particularly touching aspect to the portrait of the gigantic woman.

Totally absorbed in her activity, she radiates a rather melancholy calm – a characteristic of most of Picasso's pictures during this period.

This effect is supported by the color scheme, which is typically muted; the so-called *grisaille* technique (gray on gray) has traditionally been used to imitate sculpture. It is possible that Picasso saw this classical sculpture during his visit to Rome.

Pushing back Boundaries

In the early 1920s Picasso created figures to which he gave unrealistic anatomies, figures of enormously exaggerated size and shape. His paintings were now populated by human beings with gigantic bodies and small heads. But it was precisely through such exaggeration that Picasso evolved a new and very individual artistic idiom, one which allowed him to make statements about content by means of form – that allowed him, for example, to convey energetic movement or profound stillness. Featuring huge, disproportionate figures, the paintings of this period possess a tremendous power.

Picasso often turned to the classic theme of bathers, or similar subjects related to life by the sea. These works, through their depiction of the basic elements of air, water, and earth emphasize their figures' closeness to nature; at the same time, they also refer to the culture of classical Greece. The massive figures stand out boldly from the barely indicated background, in which sky and sea are often simply areas of color placed one above the other with no attempt at perspective.

Picasso's interest in distortions of reality in favor of new forms of expression, however, also related, as we have already seen, to his keen interest in photography. This medium interested him largely because it

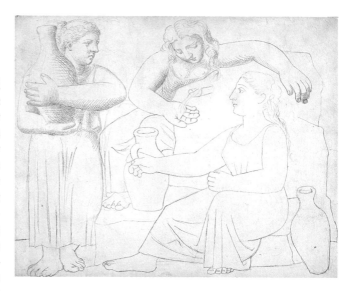

allowed him to manipulate the twin concepts of representation and reality, especially as it is a medium valued for its supposed objectivity. His experimentation with form and proportion led him logically to a renewed encounter with means of expression. From representation based on classical forms and models, Picasso now moved toward surreal alienation and distortion, and thus to a new turning point in his work.

Gigantic creatures… intrepid women with oversized hands and wondrous feet, such as have never been seen before.

Ramón Gómez de la Serna, 1961

Three Women at the Spring (Study), 1921
Pencil on primed wood
21 x 27 cm
Paris, Musée Picasso

Three monumental women are seen gathered around a spring. The blend of ideal portrait – the classical profile of the woman on the right corresponds to an ideal type – and disproportionately large bodies results in a totally new type of figure, one which radiates balance, repose and harmony.

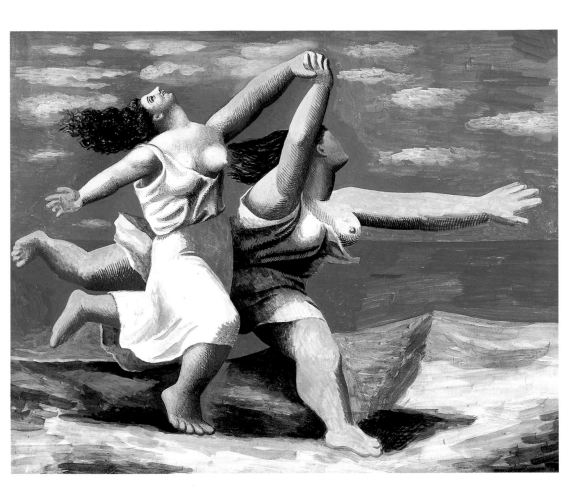

Women Running on the Beach (The Race), 1922
Gouache on plywood, 32.5 x 42.1 cm
Paris, Musée Picasso

This study of movement is an outstanding example of Picasso's experiments in form at this time: two women are seen running along a beach with a blue ocean for background. Moving with elemental force, they throw back their small heads and fling their massive arms upward in a gesture of joyous abandon. Arms and legs appear gigantically enlarged and monumentally broad, but the large feet are placed on the ground with a degree of delicacy.

The description of the surrounding landscape is very simple – everything is concentrated on the rapid movement of the women.

This design for a theater curtain for the ballet *Le Train bleu* can be seen as the precursor of a new development in Picasso's work: the stretching and distorting of bodies was to be taken further a little later in his Surrealist phase. For the time being, however, anatomy and the relationship between forms remain recognizable, and the composition of this picture is balanced and harmonious.

Picasso and the Art Market

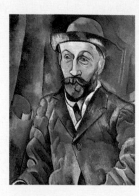

Portrait of Clovis Sagot,
1909
Oil on canvas
82 x 66 cm
Hamburg, Festhalle

Picasso knew that one day he would make a living from his art. Unlike many of his colleagues who became famous only in old age or after death, Picasso achieved success in his youth; he was able to celebrate the occasion of his first exhibition at the age of 20. Through his father, the painter and art teacher Don José Ruiz, Picasso was already familiar with the market value of works of art long before he came into contact with his first patrons and gallery owners in Paris. Art dealers were at first a challenge for Picasso, since they had their own welfare primarily in mind; this was particularly true of Clovis Sagot, who represented Picasso and most of the new arrivals in Paris.

The gallery owner Ambroise Vollard, who had already represented Cézanne, Van Gogh, and Gauguin, organized the first exhibition of works by Picasso in Paris in 1901 – at a time when the latter already had a regular income, at least for a time, through his contract with the industrialist Pedro Manach. Picasso's early days in Paris also saw the first important purchases of his work by the sister and brother Gertrude and Leo Stein. It was through these circles – well-to-do intellectuals, poets, and established painters – that Picasso became "the talk of Paris." From 1906 until his

death in 1939, Vollard was a keen observer of Picasso's artistic development, a man wealthy enough to buy practically the whole contents of Picasso's studio; but there were others seeking to acquire the work of this promising young Spaniard. There was, for example, the German art historian Daniel-Henry Kahnweiler, who had become a dealer in order to handle the works of the French avant-garde. During the Cubist period Kahnweiler was to support Picasso in a decisive manner, both by writing about him and also by buying his latest works. Born in 1884, the son of a businessman, Kahnweiler, who had been subjected to severe hardship during both

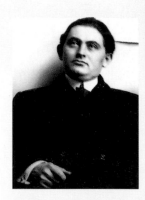

Daniel-Henry Kahnweiler in Picasso's studio on the Boulevard de Clichy, 1910
Photograph by Picasso

Ambroise Vollard, ca. 1930
Photograph by Thérèse Bonney

Catalog of an exhibition at the Galerie Berggruen, Paris, 1954

world wars because of his Jewish origins, survived Picasso by five years and so was able to follow his career into old age. He was probably the most committed of Picasso's art dealers, and demonstrated both a genuine enthusiasm for Picasso's work and a real understanding of it.

Between 1911 and 1914 Picasso's fame increased greatly as a result of exhibitions in New York, London, Munich, and Vienna, and pictures were sold for astonishing sums. The role played by the art market in Picasso's rise to public acclaim, in the creation of the Picasso myth, can hardly be overstated. While at the beginning of his career the art dealers often made use of Picasso and dictated their own prices, it was now increasingly the artist who conducted the sale, and who chose to whom he would offer his works, and where he should exhibit. Françoise Gilot describes very graphically how skillfully Picasso played off the art dealers and gallery owners against each other during 1944 and 1945: "This was one of my first insights into Pablo's classic methods of treating people like bowling pins, hitting one with a ball in order to bring another one down."

But the true Picasso boom was encouraged by the prosperity of the postwar years. Since then, one auction price record has rapidly been surpassed by another, and Picasso's works, like those of some other artists, have been

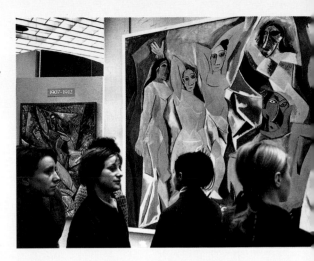

sold for fantastic prices – a fact that often reflects the state of the art market rather than the quality of the works themselves.

Retrospective at the Grand Palais, Paris, 1966

Picasso with the gallery owner Heinz Berggruen, Cannes, 1962

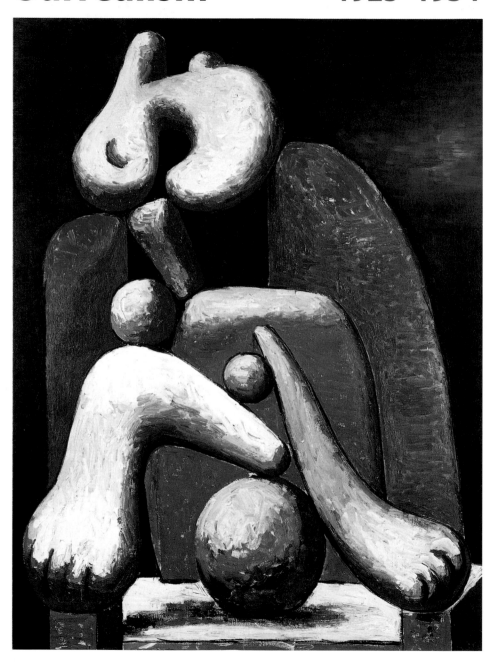

During the period 1925–1934 Picasso pushed the separation of form and content even further. The writer André Breton introduced him to Surrealism, and for several years he was linked to the new movement by shared aims and interests, exhibiting works at the first Surrealist exhibition of 1925. Soon, however, he loosened his ties with the Surrealist group, determined (as always) to pursue his own artistic path. During these years Picasso also came to grips with sculpture, allowing the experience he gained in that medium to flow into his paintings and drawings.

His marriage to Olga, however, now ran into difficulties, and from 1927 a young girl, Marie-Thérèse Walter, was his secret mistress. When she gave birth to their daughter, Maya, in 1935, Picasso's marriage collapsed.

Lindbergh with his aircraft

Picasso, ca. 1930

1924 André Breton's *Surrealist Manifesto* published in October.

1927 US aviator Charles Lindbergh flies non-stop across the Atlantic.

1928 Discovery of penicillin.

1929 Crash on the New York Stock Exchange sets off worldwide industrial crisis with far-reaching consequences.

1933 President Hindenburg appoints Hitler as Chancellor of Germany.

1925 Picasso takes part in the first group exhibition of Surrealist painters at the Galerie Pierre, Paris.

1930 He acquires the small château of Boisgeloup in the *département* of Eure, northern France. In the USA, several important exhibitions, including works by Picasso, are mounted.

1932 The art historian Zervos publishes the first volume of his catalog of Picasso's works (works from 1895 to 1906).

1933 Picasso tries without success to prevent the publication of Fernande Olivier's memoirs.

1934 Makes an extended journey to Spain with Olga and Paul.

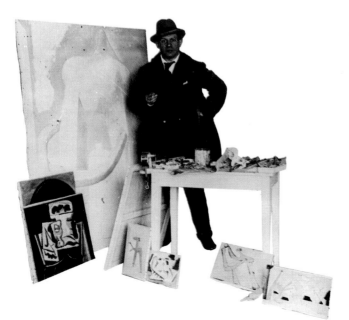

Opposite:
Woman in Red Chair, 1932
Oil on canvas
130.2 x 97 cm
Paris, Musée Picasso

Left:
Picasso in his studio, 1919
Anonymous photograph

Juggling with Forms

Since the mid-1920s Picasso had been aggressively pursuing his experiments in form, increasingly freeing his figures from any connection with nature. With his gigantic, two-dimensional acrobats and swimmers, for example, only a few points or outlines can often be interpreted as descriptions of bodily parts – an eye, a hand, or a foot.

While Picasso continued to experiment with line and its relationship to surface area, he was also experimenting with ideas about sculptural forms, for he was now working intensively on new sculptures, building structures from wire and other metals as well as casting heads and figures in bronze. It was typical of Picasso that he immediately transferred these new experiences to painting: in a series on the theme of bathers he captures on two-dimensional canvas the tangible forms of sculpture, its mass in space. As with the *Figures on the Seashore* (below), human beings are reduced to spherical or conical component parts, which, loosely connected, are only recognizable as men or women, or indeed as human beings at all, by a few economically inserted elements, such as breasts or eyes.

These constructs, which have come a long way from reality, and which offer a rich play of imagination and association, were completely in harmony with the ideas of Surrealism, a movement that was emerging at this time. Picasso, who had met the movement's leading figure, the writer André Breton, in the summer of 1923, was to keep in close contact with its

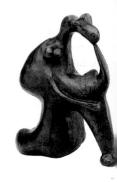

Metamorphosis (Bathing Woman), 1928
Bronze
h. 22.8 x w. 18.3 x d. 11cm
Paris, Musée Picasso

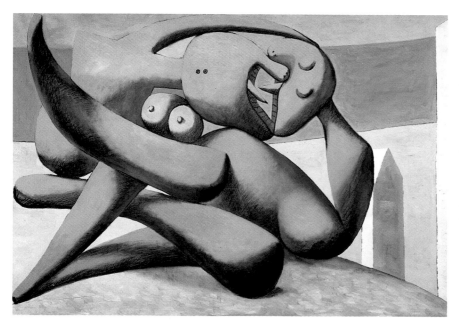

Figures at the Seashore, 1931
Oil on canvas
130 x 195 cm
Paris, Musée Picasso

Two figures with mouths gaping wide open are entwined at the beach – are they kissing or fighting? The answer appears to be irrelevant; the artist's central concern is with the fragmentation of form. With its apparently arbitrary, cylindrical elements, this large image looks very like a bronze sculpture.

writers and artists for several years. It was Breton who, in his first *Surrealist Manifesto*, published in 1924, defined the aims of Surrealism: of central importance, he insisted, was the need to draw upon the power and expressiveness of the unconscious, of the dream world, to the total exclusion of rational and realistic methods of representation. Picasso's play with forms, his free handling of all artistic media, initially linked him closely with the Surrealists, and in 1925 he took part in their first joint exhibition. Soon, however, differences of opinion and intention made themselves felt; for while Surrealists such as Joan Miró, Salvador Dalí, and Max Ernst wanted to arouse or express the deepest feelings of the observer, Picasso was always more concerned to depict his own creative confrontation with reality. In other words he was far less interested in giving form to emotional or spiritual experiences than in exploring the artistic process itself – the translation of the familiar, recognizable reality of things into an abstract language of artistic forms.

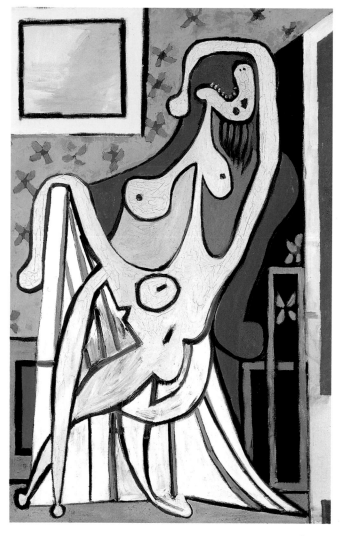

Large Female Nude in Red Chair, 1929
Oil on canvas
195 x 129 cm
Paris, Musée Picasso

While the space around this nude figure blazes with brilliant color, the figure herself is without color. Reduced to a bare outline, she writhes in the chair as though being tortured. With her widely gaping mouth she screams out her pain – a posture of torment and despair that also appears, several times, in the later work *Guernica* (pages 68–69). Perhaps Picasso was here expressing the violent crisis in his marriage to Olga, which at this time was causing great pain, particularly to her.

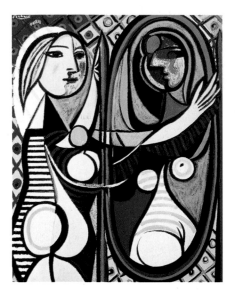

Harmony and Sensuality in Portraits

Picasso's experiments with form and his intensive play with distorted proportions were interrupted from 1927 onward by a series of portraits of fair-haired women. Seeming unusually self-contained and well-balanced, these portraits stand apart from Picasso's other works of this period, which often have an aggressive character.

At this point Picasso's private life was having a very direct effect on his art. There were persistent tensions between Olga and himself, and the couple now had very little in common. In 1927, when the artist, now 45 years old, noticed a young woman in front of the Paris store Lafayette, he approached her with

Girl in Front of a Mirror, 1932
Oil on canvas
162.3 x 130.2 cm
New York, The Museum of Modern Art

This depiction of the young Marie-Thérèse in front of a mirror was singled out by Picasso himself as a particularly important work. In a subtle contrast, the painter shows the side view and the mirror reflection of the young woman: unlike the multi-layered small areas of color in the side view, the mirror image is enclosed by flowing outlines and large monochrome areas of color. Various shades of red are placed next to deep gray and vivid green – it seems as though the lively exterior is being confronted by a sensual yet calm interior.

the words: "My name is Picasso – I would like to paint you!"

Marie-Thérèse Walter, then 17 years old, soon afterwards became Picasso's secret mistress and the model for some of his most sensual portraits.

No other woman ever stimulated Picasso to the creation of such intimate and emotional portraits; no other woman was portrayed by him – in paintings, drawings, etchings, and sculptures – in such a sensual and yet calmly self-contained manner. In most of the pictures he shows Marie-Thérèse sleeping or sitting, and in these poses she appears relaxed and entirely at ease with her circumstances. Unlike his Cubist and Surrealist fragmentations, his images of her always depict a figure in gently rounded outlines, the colors warm and harmonious. Often naked, she

Marie-Thérèse at 13

The Red Chair, 1931
Oil and enamel paints
on plywood
130.8 x 99 cm
Chicago, The Art
Institute

If one compares this portrait of a woman with the *Large Female Nude in Red Chair* from the artist's earlier Surrealist phase (page 57), it is easy to recognize the influence of Picasso's own personal life on his art. While earlier everything was in turmoil and disharmony, here only serenity and calm are communicated by gently curving lines enclosing the whole figure.

Reduced to flat areas of color surrounded by clear outlines, the elements of this image are almost organically connected: though not naturalistically reproduced, all the limbs appear to

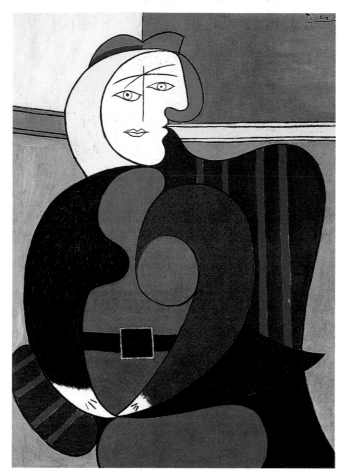

belong to a body in tune with itself. What is more, by means of the same formal treatment the surrounding space is also drawn into this organism, so that this picture represents a high degree of harmony between the sitter and her environment.

The composed facial expression of the woman supports this impression, though Picasso is trying something new here, fusing the frontal view and the profile into one image. In this painting we have a combination of Cubist multiple views and Neoclassical clarity – a synthesis which was to become important in Picasso's later work.

has the appearance of a goddess of love, the epitome of sensuality, totally removed from time. The artist's experience of physical love and tenderness was clearly reflected in these portraits, resulting in works of a pure and serene beauty.

Despite his passionate relationship with Marie-Thérèse, it was not until 1935 that Picasso and his wife Olga separated. In October of that year, his young mistress gave

birth to their daughter María de la Concepción, known as Maya. Later Picasso called this tension-charged period "the worst time of my life." Yet, as so often during his life, the conflict resulted in exceptional artistic productivity.

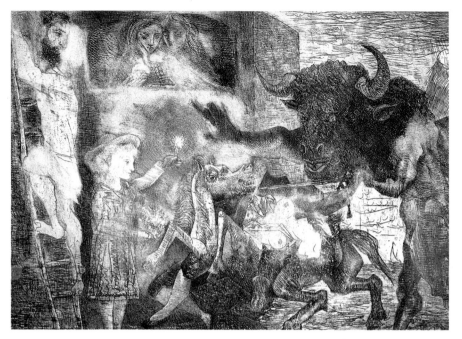

With great dramatic emphasis, Picasso here creates a very compact and busy scene, constructed almost like a stage set. To the left in the background is a dark building in which two women with a dove observe events as if from a box at the theater. In the foreground is a concentration of terror: from the right, the minotaur intrudes powerfully into the image, his gigantic skull and weapon threatening the other figures. In front of him a horse has collapsed, and over its back lies a woman in the costume of a torero, as if dead, with one breast bared. At the left-hand edge is a bearded man is climbing a ladder. The only figure to offer resistance to the brutal intruder is the young woman, her arm raised holding a candle, which casts a light of hope into the dark space.

While this work is capable of several psychological interpretations, it remains above all a metaphor of oppression, of the intrusion of violence into human existence.

Minotauromachia

Picasso's preoccupation with the minotaur motif during the 1930s can be seen as an expression of a deep unhappiness at this time, for he was now concerned not only about the worsening political situation but also about his personal life. The political situation was increasingly uncertain – Fascism and National Socialism were casting their dark shadows over Europe – and Picasso's personal situation just before the collapse of his first marriage was one of pain and deep sadness. The minotaur was his means of coming to terms with his distress.

The minotaur – that hybrid creature from Greek mythology, half man and half bull – first appeared in Picasso's work in 1928. This fabulous being had already inspired many artists, and was to become a symbol of particular significance for the Surrealists.

Picasso's most impressive minotaur image is probably his etching *Minotauromachia* of 1935, one of his most significant and most enigmatic works. The minotaur pushes his way into the image from the right, threatening the other figures with his weapon and his brutal physicality – all that stands in his way is a girl with a bunch of flowers, holding a burning candle toward him.

Picasso also takes up the theme of the mythical bull-man in many portraits of this period, linking it, in mostly somber and enigmatic ways, to dying figures and to situations of

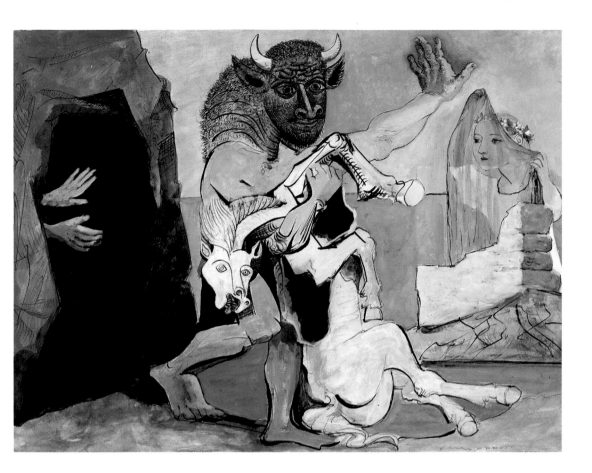

menace. For Picasso, the minotaur seems to have embodied untamed natural forces, and so combined terror with vitality. It may be assumed that Picasso identified this hybrid being with himself, and expressed through it both his own masculinity, and also his artistic genius, which often made him feel isolated and lonely.

Created during the politically unstable 1930s, however, these works were also an expression of the anxiety that Picasso felt toward the increasing power and terror of the political regime. But, as was usually the case, Picasso's statements about current events remain in the background; he becomes more explicit, more overtly political in 1937, in his famous work *Guernica*, a painting in which the violence of the time found expression in both form and content.

Minotaur and Dead Mare in Front of a Cave, A Young Girl Opposite, 1936
Gouache and India ink on paper
50 x 65.5 cm
Paris, Musée Picasso

Line as an Element of Form

Above:
Celestina, 1904
Oil on canvas
81 x 60 cm
Paris, Musée Picasso

Jean-Auguste-Dominique
Ingres
Woman Bathing, 1808
Oil on canvas
146 x 97 cm
Paris, Musée du Louvre

Whether defining an outline or indicating contour, line was always of particular significance for Picasso. This is largely as line plays a key role in the formal structure of a painting or graphic work, and for Picasso the formal elements of his works were usually more important than their subject.

Picasso had become fascinated by the works of the Neoclassical artist Jean-Auguste-Dominique Ingres (1780–1867) during his early years in Paris, when he was able to study Ingres' works in the Louvre Museum. Ingres' large female nudes are of crystalline clarity, their consciously elegant outlines being particularly important. Here it should be noted that Ingres' 'lines' are not literally drawn, but come into being through the contrast between two areas of color.

For Picasso, too, form and its transmutations often had greater significance than the actual content of the picture. In a work such as *Celestina* (left) from the Blue Period, the form-giving line still has the task of supporting the content – here the outline created by the contrast of colors expressively emphasizes the isolation of the person depicted. But soon afterward, in his Cubist pictures, Picasso destroyed the closed linearity of the outline and fragmented it into new combinations of individual elements.

Line thus acquired an individual significance as a pictorial element, a significance Picasso was constantly re-examining and redefining throughout his work, most notably, for example, in the 1920s, in his drawings and paintings based on photographs (page 46). In the reduction of a photograph's fine shades of gray to simple outlines, the bodies depicted, and their surroundings, become two-dimensional and abstract. But Picasso opposes this outline, which in this way acquires an 'anti-spatial' effect, with a descriptive contour line with which he indicates bodily shapes, folds of fabric, pockets, etc. Since he often does not support this description with modulated coloring – so that the volume does not have a truly 'sculptural' effect – the line acquires a significance, in fact becomes a symbol, and thus the picture's central focus.

But as early as the late 1920s and early 1930s, Picasso took a decisive step further. In the picture *The Studio*, for example, lines have descriptive – and in places also form-giving – functions, but Picasso challenges their clear significance by allowing the

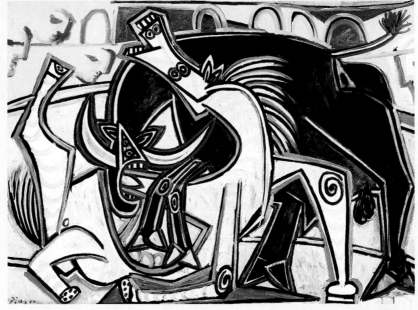

areas of color they circumscribe to become transparent: lines can be seen through them. Thus constructed, the elements of the picture, ambiguous in the way they are to be read, now consist only of color and line; in effect, both of these formal elements have become the independent content of the picture.

In a very similar manner, Picasso explores the relationship of line and space in the sculpture *Design for a Memorial to Apollinaire* (right). The originally form-giving function of the line is put in question here by the fact that the volume of the sculpture is completely open and so includes empty space. Picasso's interest in drawing, in the effect of the line on the structure of the

image, runs through his whole work and gives his line an ever-changing function. But at least from the 1930s onward it is possible to speak of a formal continuity that runs through his work and may to this extent be considered typical of Picasso – in Picasso's work line always has an intrinsic aesthetic value.

Most often black, sometimes brightly or even luridly colored, Picasso's line describes areas of space, volumes, and surfaces, and sometimes frees itself from this function to such an extent that – particularly in his late work – it is transformed into pure painting.

Bullfight, 1934
Oil on canvas
97 x 130 cm
Atherton, Collection of Mr. and Mrs. Harry W. Anderson

The Studio, 1928
Oil on canvas
149.9 x 231.2 cm
New York, The Museum of Modern Art

Right:
Figure (Design for Memorial to Apollinaire), 1928
Iron wire and sheet iron
h. 50.5 x w. 18.5 x d. 40.8 cm
Paris, Musée Picasso

The "Barbarian" Years 1937–1946

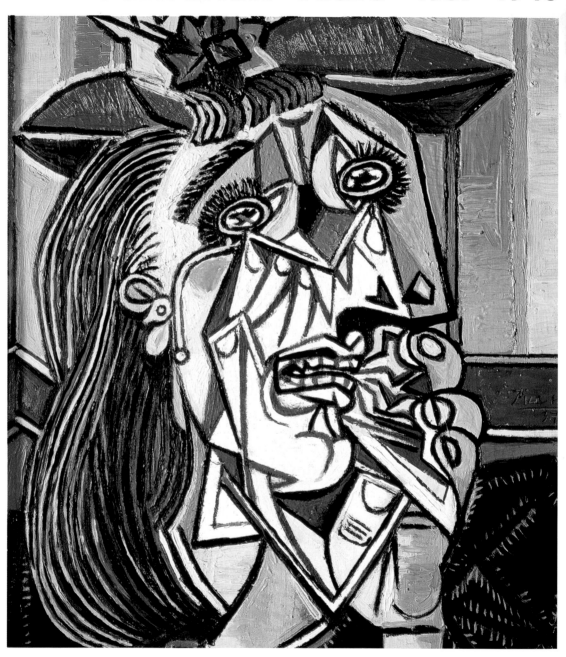

A period of violence, fear, and death had dawned. Picasso's works during this dark period of war and social turmoil – the "Barbarian" years – are deeply marked by political and personal catastrophes. The Spanish Civil War came to a cruel climax in the bombing of the Spanish town of Guernica, and Picasso's response was probably his most famous picture, which he painted within a few weeks of the event. The young Yugoslav photographer Dora Maar took pictures of the various stages of development of the painting; during this time she became Picasso's model on many occasions, and then his mistress. After the occupation of France by German troops Picasso lost his closest friends and artistic contacts, and retreated further into his studio and into his art. Nevertheless, the world had begun to pay attention to him: in 1939 the New York Museum of Modern Art mounted a great Picasso retrospective.

Movements of troops during the Spanish Civil War

1936 Start of Spanish Civil War (ended 1939 with General Franco's victory over the Republicans).

1938 Pogroms in Germany; synagogues and Jewish institutions destroyed.

1939 World War II begins.

1945 German capitulation. US atom bombs exploded over Hiroshima and Nagasaki. End of World War II.

Picasso, 1933
Photograph by Man Ray

1936 Large Picasso retrospective in Barcelona, then in Bilbao and Madrid, later in London and New York.

1937 Picasso paints the large-format wall-painting *Guernica* for the Spanish pavilion of the Paris International Exhibition, to a commission from the Republican Government of Spain.

1939 Ambroise Vollard suffers a fatal accident. *Guernica* is shown in New York, Los Angeles, Chicago, and San Francisco.

1943 Picasso meets the young painter Françoise Gilot, who visits him frequently at his studio.

1944 In March a private reading takes place at the Leiris Gallery of Picasso's drama *Desire Caught by the Tail*. Albert Camus directs, and the cast includes Jean-Paul Sartre and Simone de Beauvoir.

Opposite:
Weeping Woman, 1937
Oil on canvas
60 x 49 cm
London, Tate Gallery

Right:
Man with Lamb, 1943
Bronze
h. 222.5 x w. 78 x d. 78 cm
Paris, Musée Picasso

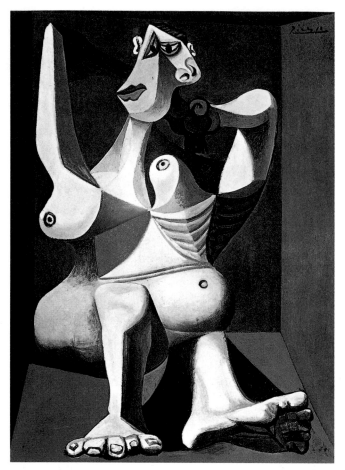

The "Picasso Style"

In this uncertain, difficult time of war, and particularly during the occupation of France by the Germans, Picasso's style was marked by the threats and anxieties suffered by the artist and by those around him. After many of his friends and colleagues had been arrested or had found it necessary to flee from the German occupying forces, Picasso began to feel increasingly isolated, without any possibility of artistic dialog. In his pictures he worked through this situation with a highly individual language of forms, a language that later came to be called the "Picasso style."

Essentially, Picasso combined two principles of representation, the "figurative" and the "dissociative." Figurative painting is based on the laws of perspective and use of nature as a model. Dissociative painting, by contrast, frees itself from the single-perspective viewpoint: the front and back view are seen simultaneously in the same picture, objects and individual parts of the body appear as if dispersed – dissociated – and there is no longer any outline to indicate the "natural" shape of an object. Both methods of composition are found in Picasso's early work: the figurative from his paintings before 1905 and his Neoclassical period, and the dissociative above all in his Cubist paintings.

But now figuration and dissociation in Picasso's work were blending into a synthesis, and it is this synthesis,

Woman Combing her Hair, 1940
Oil on canvas
132 x 97.1 cm
New York, The Museum of Modern Art, Louise Reinhardt Smith Bequest

This portrait of a seated naked woman, which was preceded by several studies, represents a high point in Picasso's wartime works. A woman is seated in a very narrow space, tidying her hair with her hands. Only in a few aspects does the figure appear to be painted from nature – arms, legs, and abdomen appear to be parts that have been separately modeled and then combined, the breasts point in different directions. The face, strangely distorted, is seen from several viewpoints. Here the fundamental elements of Picasso's new style are combined in a way that powerfully expresses the sense of menace he felt at a time when the political situation across Europe grew darker day by day.

together with the use of the typical trademarks of children's drawings (such as drawings of matchstick men and simplified body shapes), that characterizes the "Picasso style." His new pictures show people and things that are structured by line, and viewed from several perspectives, but that nevertheless remain related to their natural appearance.

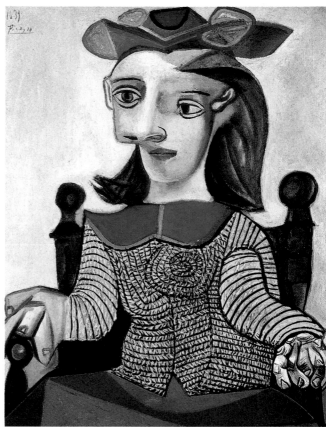

Dora Maar, 1936
Photograph by
Picasso

The Yellow Pullover (Dora Maar), 1939
Oil on canvas
81 x 65 cm
Berlin, Sammlung Berggruen in SMPK

In this unusual, majestic portrait of a young woman, who sits enthroned on a dark willow chair, Picasso is depicting the Yugoslav photographer Dora Maar, whom he met in 1937 and who soon afterward became his mistress. While Picasso's distinctive style is very evident in this picture, with lines on the yellow pullover, for example, seeming to have a life of their own, the portrait is clearly a likeness and was evidently painted from the living model. It clearly conveys the particular character of the subject: "She did not say very much, made no gestures at all, and in her behavior there was something that went beyond dignity – a certain rigidity," was how Françoise Gilot later described the appearance of Dora Maar.

Guernica

In the wall painting on which I am working, and which I am going to call 'Guernica,' and in all my latest works, I am openly declaring my revulsion against the military caste which has submerged Spain into an ocean of suffering and death.

Pablo Picasso

Picasso's monumental mural *Guernica* is a record of the terrors and suffering of war. It was painted when Picasso heard of the bombing of the sacred town of the Basques, Guernica, on April 26, 1937. On that day, air force units under German leadership destroyed the small Spanish town within a few hours, in support of General Franco and his associates, who were conducting a coup against the lawful government of Spain.

After its destruction, and largely as a result of Picasso's famous picture, Guernica became a powerful symbol of the brutal Spanish Civil War. From the beginning Picasso had aligned himself with the legitimate Republican government, which in early 1937 commissioned him to produce a mural for the Spanish pavilion of the Paris International Exhibition, to be opened in July. The news of the dreadful bombing provided Picasso with his horrific theme, and he expressed his shock in a sensational work that he created in just a few weeks of breathless activity, between May 1 and June 4.

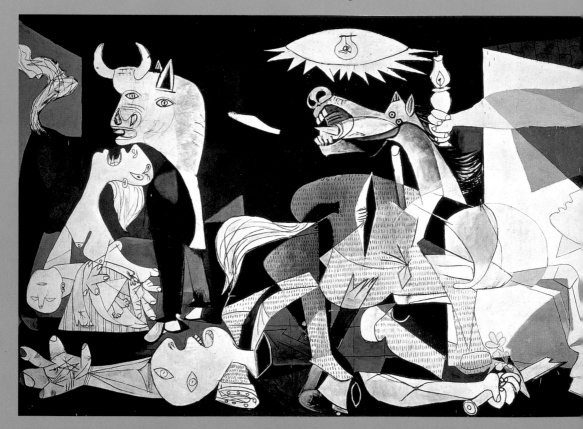

Study, 1937
Pencil on blue paper
26.9 x 21 cm
Madrid, Museo Nacional
Centro de Arte Reina Sofia

Guernica became a powerful image of the destructive forces that threatened human life and civilization. Here Picasso found a universally comprehensible way of expressing humanity's suffering. All color has been banished from the painting; only gray, black, and white remain, to emphasize the despairingly somber mood of the scene, which could be taking place indoors or out, by day or night, it is not clear. With dramatic movements and anguished expressions, the figures collapse, fall, scream. All are victims, both human and animal: at the left-hand edge of the painting there is a wailing mother with her dead child in her arms; above her there is a roaring bull; and in front of her lies the crushed body of a dead warrior, from whose broken sword a flower grows. From the right, a hunched woman seeking help rushes forward; above her is a figure staring in horror, bringing light into the darkness. On the right, a desperate figure throws her arms up in horror and despair. Just to the left of the center there is a wildly rearing horse above which shines a lamp in the form of an eye enclosing a light bulb. Is this the eye of God, or a bomb?

Here Picasso was making use of stylistic methods and motifs he had worked out in the preceding years, invoking Cubist multiplicity of forms, Surrealist distortions of form and size, and simultaneous perspective. Here Picasso also employs, for the first time, the language of children's drawings, with its simplified forms and signs. Two-dimensional depictions are combined with frontal and profile views, bands of color-tone overlap the outlines of the figures – and yet everything is clearly directed toward making the observer vividly and inescapably aware of the victims' pain and suffering; the elemental gestures of anguish clearly demand a deep sympathy. Rarely has the cruelty of war been expressed as explicitly as in *Guernica*. Here Picasso created a timeless image of terror and violence waged against man and beast.

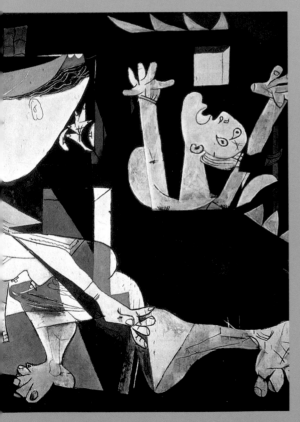

Guernica, 1937
Oil on canvas
349.3 x 776.6 cm
Madrid, Museo Nacional
Centro de Arte Reina Sofia

Head of a Weeping Woman with Red Tears, 1937
Pencil, colored chalk, gouache on paper
23.5 x 29.3 cm
Madrid, Museo Nacional
Centro de Arte Reina Sofia

Retreat

Dark clouds were spreading across Europe. With Franco's seizure of power in Spain, Picasso was now denied contact with his homeland. In Paris he was becoming increasingly isolated both artistically and personally as close friends were forced into exile, arrested after the German army had marched into France, or had to go into hiding.

Picasso, who had set up a studio in Royan on the Atlantic coast, at first traveled back and forth between the coast and the capital, but had to stop in 1940 after the occupation of Paris. Increasingly he retreated into his studio in the Rue des Grands-Augustins in the Latin Quarter of Paris, soon also using it as his living accommodation. There he surrounded himself with the few

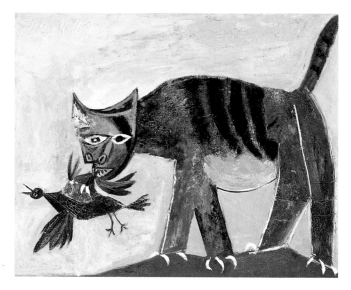

Cat Catching a Bird, 1939
Oil on canvas
81 x 100 cm
Paris, Musée Picasso

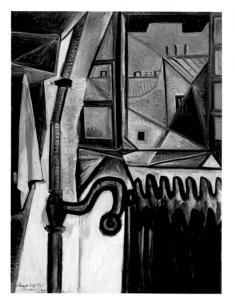

Studio Window, 1943
Oil on canvas
130 x 96.5 cm
Jerusalem, Israel Museum

literary and artistic friends who remained in Paris.

Things were now very difficult. Paris was occupied by German troops; as a known opponent of Franco he was banned from exhibiting; and people were feeling the material and psychological hardships caused by war and occupation. Picasso now painted a series of portraits of women, animal paintings, and still lifes.

Although these pictures do not directly use the war as their theme, they clearly show by means of color, structure, and subject the threat to which Picasso felt himself exposed. As he explained later: "I did not paint the war, because I am not one of those artists who go around like photographers in order to record events. But I have no doubt that the war is contained in the pictures I have painted."

Awkward, distorted forms, narrow spaces, and animals that devour each

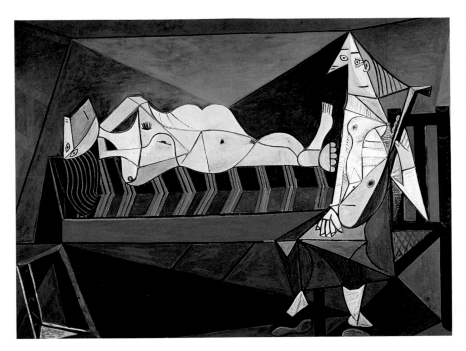

Aubade, 1942
Oil on canvas
195 x 265.4 cm
Paris, Musée National
d'Art Moderne,
Centre Georges
Pompidou

This painting, which was heralded by numerous studies, is among Picasso's most famous works. In rich contrast, two women are seen opposite one another in a narrow, dark space. The representation of both figures is restricted to lines and lightly modulated areas of color, but a striking contrast exists between them: the position of the recumbent woman is emphasized by an earthy coloration, while the restless colors and the attentive attitude of the seated figure lend her a nervous character. It is often assumed that in this painting Picasso was expressing the tension in his relationships with both Marie-Thérèse and Dora Maar. It may also be an expression of the somber mood of the war years.

other became symbols of violence and aggression. His dark still lifes, furnished with a few essential objects, bear witness to the cold and solitude that now surrounded him, this man of such vitality. Forced back on the few meager objects of his environment, he now put these powerfully into the picture, describing the simplest domestic utensils in an often dramatic manner in his sober still lifes, which were painted with a reduced palette and which have a two-dimensional appearance. While he did not directly involve himself in politics at this time, he always kept his distance from the enemy occupiers, and when Germans visited his studio he handed out reproductions of *Guernica* to them. To the question from a German officer as to whether this was his, Picasso's, work; the artist replied dryly, "No, yours!"

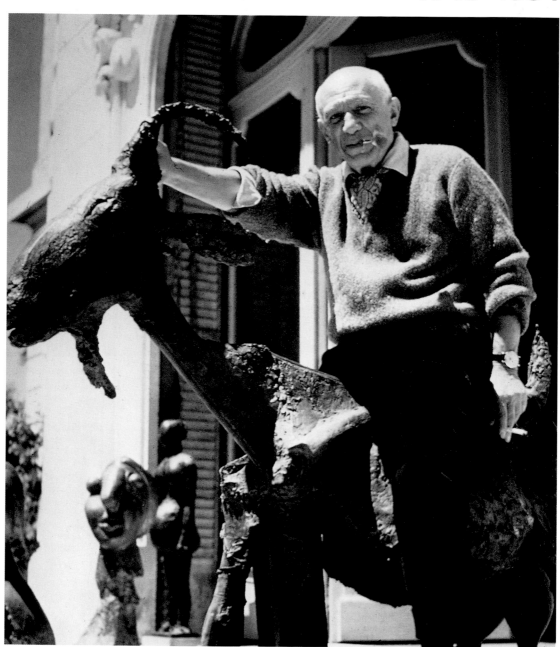

Despite the restrictions imposed by war and by the Occupation, it was at this time that Picasso's fame increased enormously. In the USA he was celebrated as the most significant artist of the 20th century, and after the Liberation he also became, at a stroke, a public figure in France. He attracted criticism for joining the Communist Party in the autumn of 1945, but his political commitment continued to be restrained. His lithograph of a dove, however, created for the World Peace Congress in Paris in 1949, became world-famous and was soon an international symbol of peace.

In the late 1940s, only a short time after Picasso had rented a pottery workshop in the little town of Vallauris in the south of France, he set up his second residence in the town together with the young painter Françoise Gilot, who now became his companion. Picasso's youngest children, Claude and Paloma, were born at this time.

The blockade of Berlin

1946 Founding of the United Nations (UN).

1948–1949 During the blockade of Berlin by Russian forces, the city is provided with supplies from the air by the Western Allies.

1950–1953 Military clashes between the communist North and the capitalist South Korea, a conflict that draws in the superpowers.

1953 Workers' revolt in the German Democratic Republic on June 17.

1954 Death of Henri Matisse.

Picasso in a pottery workshop

1947 Picasso moves to Vallauris during the summer and creates many ceramic works; he lives with his family at the villa 'La Galloise.' In August he travels to the International Peace Conference of intellectuals in Breslau (Wrocław), visits Warsaw, Krakow, and Auschwitz. Numerous exhibitions; in November, the first large ceramic exhibition in Paris.

1951 On the occasion of his 70th birthday, there is a large retrospective in Tokyo, and exhibitions of sculpture and drawings in Paris and London.

1953 After a quarrel about a portrait of Stalin by Picasso, he breaks with the Communist Party.

Opposite:
Picasso in front of his house at Cannes and his sculpture _The Goat_, ca. 1954
Photograph by Rizzo

Right:
Poster for the World Peace Conference of 1949 with Picasso's image of a dove

CONGRÈS MONDIAL
DES PARTISANS
DE LA PAIX

SALLE PLEYEL
20-21-22 ET 23 AVRIL 1949
PARIS

Picasso's Political Commitment

After the war Picasso had become an international public figure, and his life and work were suddenly the subject of countless articles and publications. His entry into the Communist Party of France in the autumn of 1944 therefore caused a great commotion. For Picasso, this step was the logical consequence of his wartime experiences, and he now wanted to take a political stand: "Were the Communists not the most courageous people in France, in the Soviet Union, and in my homeland, Spain? How could I have hesitated?... And then I was so eager to find a country of my own again: I had always been an exile, now I was not one any more..."

Several of his pictures from this period have a clear political content,

War, 1952
Oil on hardboard
450 x 1,050 cm
Vallauris, Temple de la Paix

These two murals present a contrast between war and peace. In the vision of peace, rounded forms and earthy color tones support the themes of harmony and community. In the vision of war, black figures are burning and murdering; the contrasts are harsh, the outlines sharp. These aggressive figures are halted by a man bearing a shield on which a symbolic dove of peace is emblazoned. The imagery and symbolism in these two murals in the Temple of Peace are simple and easily interpreted.

but altogether the group of overtly political works within his total output is very small.

As before with *Guernica*, Picasso responded to war in Korea with a very specifically titled work. After American forces moved into Korea he painted the accusatory *Massacre in Korea*, in which, in simple pictorial language, he places good and evil in opposition to each other in a vivid and unmistakable way. Still under the influence of the events in

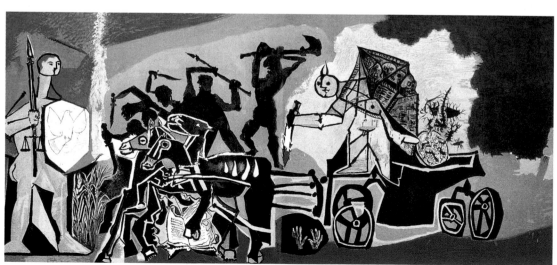

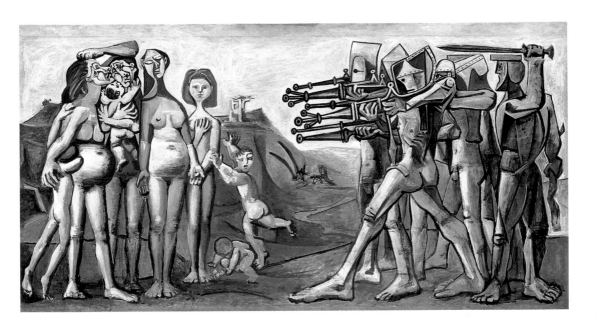

Korea, a little later Picasso rebuilt a 14th-century chapel in Vallauris as a so-called 'Temple of Peace.' Here two monumental pictures with very different color schemes depict war and peace.

Picasso's relationship with the Communist Party was brief. The free, disruptive spirit of the artist, who demanded total autonomy for his art, was unwilling to submit to Party guidelines; and for their part the Communists never really accepted his style since it could not be easily adapted to their own purposes. These differences soon became insurmountable.

Massacre in Korea, 1951
Oil on plywood
109.5 x 209.5 cm
Paris, Musée Picasso

"Here is the great picture… he had told me about: figures like robots… armed with strange machine-guns, on the point of murdering a group of women and children," was how this painting was described by the gallery owner Daniel-Henry Kahnweiler in March 1951. In a green but dreary landscape Picasso places two groups confronting each other: on one side are soldiers in the form of cruel, faceless machines of war; on the other, defenseless, naked women and children. The faces of the two women to the far left, dissolving in despair and fear, recall Picasso's earlier works, while the rest are painted with what for Picasso is an unusual degree of realism.

In this picture he has placed greater emphasis on the message of the painting than on his own artistic expression – a rare phenomenon in Picasso. What he was working with here was in effect the simplifying language of propagandist art: Picasso is making a unique concession to the Communist Party, which demanded realistic art as illustration of political content. Picasso, however, was fundamentally opposed to this type of control and soon broke with the Communists.

Picasso and Photography

Picasso kept up his interest in photography throughout his life. He had a large collection of photographs, which he used as a resource for his studies of posture and facial expression. It included hundreds of 19th-century photographic visiting cards as well as a series of ethnographic shots from West Africa, which formed the basis of Picasso's major work *Les Demoiselles d'Avignon*.

His own photographs also served as models or at least as the inspiration for paintings, an example being a photograph of Marie-Thérèse at the beach (far right), which he translated into a painting (right). But at the center of Picasso's photographic work from the very beginning (about 1904) was his own artistic photography, which constantly assumed new forms.

In his encounter with the methods and possibilities of photography he discovered the many functions this medium could have, either in direct relation to his work or completely independently of it.

With the exception of photographs he took of his own works or of colleagues, Picasso rarely created purely documentary photographs, let alone touristic views or family portraits. Admittedly, during the years 1908–1911, and occasionally later,

Picasso took numerous photographs of his friends and patrons, in which for the most part he allowed the subject to pose in front of his own works in his studio. In these pictures it already becomes clear that Picasso clearly understood the medium of photography as a means not only of self-portraiture, but also of self-expression. In photographs such as the portrait of the painter Rousseau in the latter's studio (top right),

Henri Rousseau, 1910
Photograph by Picasso
(double exposure)

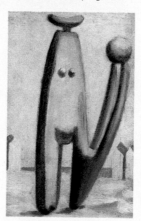

photography is shown to its best advantage, for this is not a traditional portrait of the artist with his work; through the use of double exposure, Picasso deliberately created an image that tellingly combines painter, paintings, and observer.

By means of the technical manipulation with which Picasso had been

Above:
Marie-Thérèse Walter on the beach at Dinard, 1928
Photograph by Picasso

Above left:
Woman with Beach Ball, Bathing, 1929
Oil on canvas
21.9 x 14 cm
Paris, Musée Picasso

Self-Portrait in a Mirror, 1940
Photograph by Picasso

Self-Portrait in Profile, 1927
Photograph by Picasso

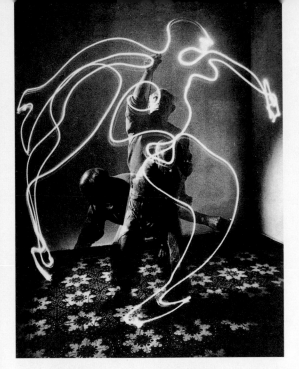

painted glass plate laid on top of the photographic paper. In these images, which he often worked on during the process of exposure to light, Picasso succeeded in overcoming the separation between photography and painting. In 1949 his interest in the artistic and technical treatment of light prompted the photographer Gión Mili to make a remarkable photographic series in which Picasso creates drawings in the air with a luminous rod (left). In these images Picasso's sure and emphatic line can be clearly seen, allowing distinct forms to be identified even without a background. The expression on his face – visible because the room was briefly illuminated during the long exposure time – shows the calm concentration that allowed him to create forms effortlessly, producing complete images. This process of capturing Picasso at work was taken up by the film-maker Henri-Georges Clouzot. In his film *Le Mystère Picasso*, he attempted to get to the root of Picasso's

Left:
Picasso painting with a luminous rod, 1949
Photograph by Gión Mili

Bottom:
Shooting the film *Le Mystère Picasso*, 1955
Photograph by Edward Quinn

Dora Maar in profile, 1936
Photogram by Picasso

creative process and artistic make-up by filming the development of a painting from the other side of a transparent canvas. These observations are fascinating documents on the life of an artist, for Picasso was in his element: he could perform and work at the same time.

preoccupied between 1910–1914, he was later able to create works that combined the depicted work of art and the photograph. While reality and representation are still easily distinguishable in these works, from 1925 Picasso was above all concerned with challenging perceptions of both art and the world. An example is his *Self-Portrait in Profile* of 1927 (opposite, bottom left). Here the head appears as a silhouette against a light-colored background that consists of a painted self-portrait seen from the front. Thus the unreal I, the shadow, intrudes into the picture frame: in other words the photograph brings together a painted portrait and a

photographed silhouette of the very person who is taking the photograph. As with many Surrealist images, we are here dealing with a conceptual work, in which the statement conveyed by the picture – in this case a slightly menacing fantasy – takes precedence over the technical aspect of photography; the fact that the photograph is 'out-of-focus' is beside the point.

In the 1930s Picasso, exploring a technique originally developed by the photographer Man Ray, freed himself entirely from the camera and worked directly with the light-sensitive paper. Those areas that later appeared as light-colored areas on the so-called 'photogram' were protected from the light by means of a

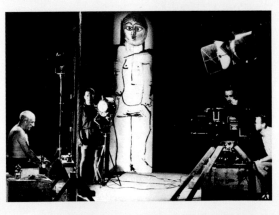

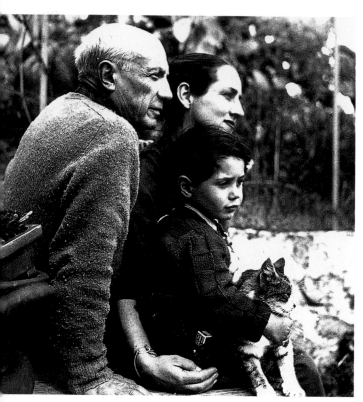

the Rue des Grands-Augustins. As always he experimented a great deal with new artistic techniques, and above all with ceramics, a medium which was to grip his imagination for several years, and with which – typically – he achieved a highly original form of expression. Having bought an old perfume factory, he set up his own pottery studio, where over the next few years he created countless plates, cups, and vases, designing and decorating them in the most imaginative ways. But lithography, too, was gaining in importance for him, and he now created a

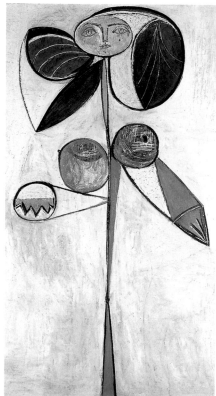

Idyll in Vallauris

During the occupation of France Picasso met the young painter Françoise Gilot, who visited him frequently in his Paris studio. This intellectual young woman increasingly attracted the artist, and eventually she became his companion. In 1948 he traveled with her to Vallauris, an old pottery-making center in the south of France, to live in his newly purchased villa, 'La Galloise.' From now on the artist spent more and more time there, gradually retreating from his life in Paris, though he kept his studio on in

Picasso with Françoise Gilot and their son Claude at Vallauris,
Anonymous
photograph ca. 1952

Françoise as a Flower (*La Femme-fleur*),
1946
Private collection

series of women's heads using this technique. Françoise often appears in his work of this period, and in a particularly fascinating way, for Picasso sometimes presented her completely metamorphosed, as a plant or a flower (opposite, below).

In 1947 Françoise gave birth to their son Claude, and two years later to their daughter Paloma; her Spanish name was a reference to the famous symbol of peace, the dove, which Picasso had created during that year.

Picasso's discovery of the world of children was worked into a range of pictorial motifs, and many of the playful sculptures he created in various media during the 1950s were inspired by his childrens' toys. Thus he transformed a toy car that had been a present to his son into the head of a baboon sculpture, its eyes being the car's headlights.

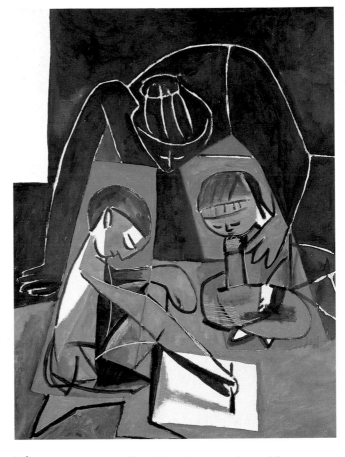

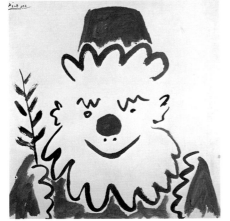

Left:
Santa Claus, 1953
Lithograph
Musée St. Denis-Seine

Claude Drawing, Françoise, and Paloma, 1954
Oil on canvas,
116 x 89 cm
Paris, Musée Picasso

In a number of pictures Picasso shows his two youngest children absorbed in play. In this painting the quiet concentration of the children is expressed by the broad areas of color extending

beyond the contours of their figures, while the unobtrusively embracing gesture of their mother, painted in delicate white lines, indicates protection. The idyll at Vallauris did not last long, for in the autumn of 1953 Françoise left Picasso and took the children back to Paris.

Sculptural Works

One day I found a bicycle saddle in a pile of old junk, and next to it a rusty set of handlebars. Quick as a flash, the two parts fused together in my mind... Without conscious thought, the idea of this "bull's head" came to me...

Pablo Picasso

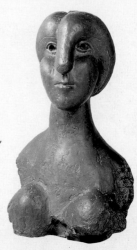

Bull's Skull, 1942
Bicycle saddle and
handlebars
h. 33.5 x w. 43.5 x d. 19 cm
Paris, Musée Picasso

The main stages in Picasso's creative life can easily be traced on the basis of his sculptures alone, for he always tried to transform his basic ideas on content and design into various media, materials, and dimensions. In their range Picasso's sculptural works cannot be compared with his paintings and graphics; but they have a special place in his output because of the very emphatic and concentrated form in which they represent his artistic ideas.

As early as his Rose Period, Picasso was concerned with expressing the mood and themes of his circus pictures without the medium of paint; in 1905, for example, he created the bronze sculpture *Fool*. But later, too, as in the bust of a woman of 1931 (below), he repeatedly transformed his current preoccupations into a physical, three-dimensional form.

There was a particularly decisive development in his sculpture during the period of Synthetic Cubism, when he moved from the two- to the three-dimensional by way of collage and then assemblage. Here his delight in experimentation was demonstrated by his desire to distort traditional notions of perspective in sculpture, and to combine the most diverse materials, some completely foreign to art. A striking example is the *Skull of a Bull*, which represents probably the most radical simplification of all: this

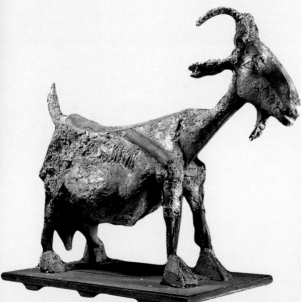

Goat, 1950
Original plaster cast (willow basket, ceramic pots, palm leaf, metal, wood, cardboard, and plaster)
h. 120.5 x w. 72 x d. 144 cm
Paris, Musée Picasso

Bust of a Woman, 1931
Bronze
h. 78 x w. 44.5 x d. 54 cm
Paris, Musée Picasso

Face (Plate), 1963
White clay, decorated with
slip, enameled
Diameter 25 cm
Basel, Galerie Bayeler

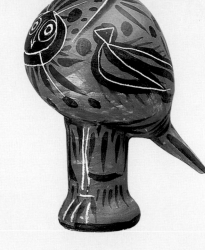

bull's head is assembled
from a bicycle seat and
handlebars, two *objets
trouvés* (found objects) he
combines into an object
that awakens associations
with his much-loved theme
of bullfighting (opposite,
top right).

By using such materials
Picasso arrived at what was
essentially a synthesis of
painting and sculpture.
During the 1940s and 1950s
Picasso experienced a
particularly creative phase

in Vallauris, where he made
and decorated countless
objects in clay. In his late
work it is above all large
steel sculptures that have
survived as the
characteristic works of an
artist who seemed at home
with any medium.

Football Player, 1961
Metal, cut out and painted
h. 58.3 x w. 47.5 x d. 14.5 cm
Paris, Musée Picasso

Owl (Drinking Vessel),
ca. 1947
Clay, painted and glazed
h. 30.8 x w. 18 x d. 27 cm
Paris, Musée Picasso

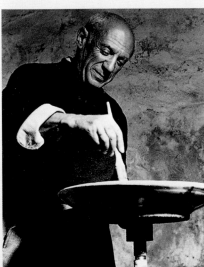

**Picasso painting a ceramic
bowl**, ca. 1948
Anonymous photograph

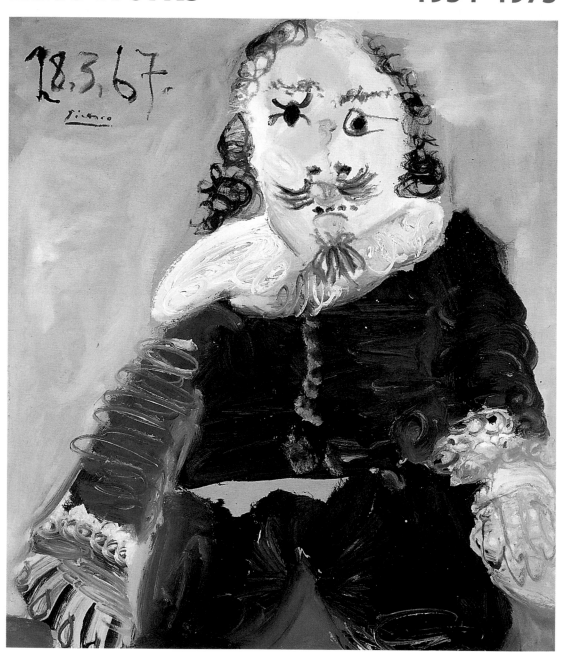

It was as a world-famous figure that Picasso spent the final part of his life: his art and his personality had become a myth. During this time he no longer took an active part in current developments in art, and gradually retreated from public life. He moved home several times, usually in a vain attempt to escape from the many people clamoring to meet him: in 1955 he bought the villa La Californie near Cannes, three years later the old mansion of Vauvenargues, and finally, in 1961, the Villa Notre-Dame-de-Vie at Mougins. In the same year he married Jacqueline Roque, who had often modeled for him since their meeting in 1953.

Toward the end of his life Picasso entered a phase of hectic productivity. As though he wanted to reassure himself again and again that his creative powers were not waning, he worked on several pieces simultaneously, painting up to five pictures a day. He was above all preoccupied with variations on the master-pieces of art history, and on the theme of artist and model.

On April 8, 1973, Pablo Picasso died at his villa at Mougins. He was 91.

Neil Armstrong lands on the Moon

Picasso, ca. 1960

1957 The Soviet Russian Sputnik, the first artificial satellite, orbits the earth.

1961 Berlin Wall built.

1963 Assassination of President J. F. Kennedy in Dallas. Vietnam War begins. Deaths of Jean Cocteau and Georges Braque.

1965 Cultural Revolution starts in China.

1969 Americans Neil Armstrong and Edwin Aldrin become first men to walk on the Moon.

1970 In Germany, beginning of W. Brandt's policy of détente toward the Eastern-bloc states.

1955 Large Picasso retrospective in Paris, which then tours to Munich, Cologne, and Hamburg.

1957 In the autumn, Picasso receives a commission from UNESCO to create a large mural at their new administrative building in Paris.

1961 His 80th birthday is celebrated by the whole art world, and numerous exhibitions are mounted in honor of his achievements.

1968 Jaime Sabartés, Picasso's longstanding friend and secretary, dies.

1973 On April 8, Picasso dies at his villa Notre-Dame-de-Vie at Mougins, at the age of 91, of a lung edema, while still recovering from an influenza attack. He is buried in the park of his château at Vauvenargues.

Musketeer, 1967
Oil on canvas
130 x 97.5 cm
Paris, Musée Picasso

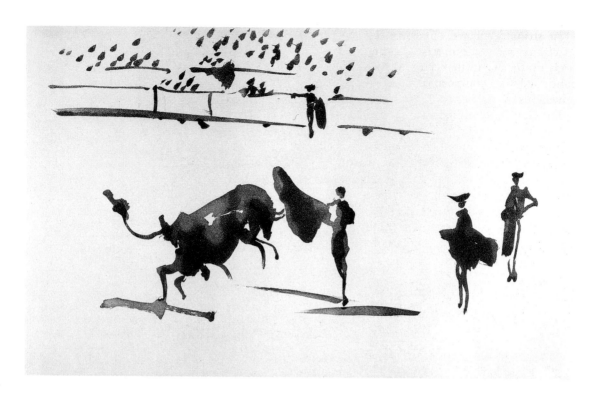

Picasso and the Bullfight

The theme of the bullfight was one that Picasso took up repeatedly in the course of his life – he had a deep love for this ancient sport and made use of the images it provided in countless ways.

The high point of this preoccupation is the lithographic series *La Tauromaquia* of 1957. He depicted bullfights with tremendous sureness of aim and technical facility. By means simply of a few precisely placed lines, spots, and signs he captured the gestures, poses, and movements of the participants during the critical moments of the bullfight. Everything is radically reduced to a few pictorial elements and the most economical graphic means: thin lines and little dots indicate the stands and spectators, while the impetuous strength of the bull and the agile elegance of the *torero* are precisely characterized with a few quick strokes. Power, excitement, and tension are all expressed with graphic means which, though minimal, are astonishingly effective.

Earlier, Picasso had repeatedly made use of the bullfight motif, but in the *Tauromaquia* series a preoccupation with an earlier Spanish artist is evident. In about 1815 Francisco de Goya had also created a *tauromaquia* series, his scenes distinguished

Play with the *Muleta*
(from *La Tauromaquía*), 1957
Etching
20 x 30 cm
Paris, Musée Picasso

by a strikingly spare indication of space that focuses our attention entirely on the events depicted. Picasso continued this compositional economy in his own series.

For Goya the bullfight was a symbol of the struggle of the Spanish people against an oppressive aristocracy. For Picasso, by contrast, it had a more fundamental significance, for the older he became the more clearly his images became metaphors: the bullfight became a symbol of the primal struggle between life and death.

Picador with Girl,
1960
Brush drawing
47.5 x 31 cm
Private collection

Jean Cocteau, Pablo and Jacqueline Picasso at a bullfight,
ca. 1960
Photograph by Brian Brake

Dish with Bullfight Scene, 1947
White clay with underglaze slip decoration
32 x 38 cm
Basel, Galerie Beyeler

Wives and Lovers

These women who had shared his life at one time or another were to go on uttering feeble squeaks of pleasure and pain and making a movement or two… enough to show that some breath of life still remained in them as they hung on a thread whose other end he still held in his hand.
Françoise Gilot, 1964

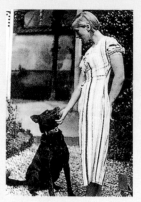

Fernande Olivier, 1908
Fernande first modeled for Picasso in 1904, soon afterwards becoming his mistress and sharing his bohemian life in Paris. In 1911, when he met Eva Gouel, Picasso's relationship with Fernande began to falter.

Picasso's relationships with women were always an important element of his art and were heatedly discussed by the public during his lifetime. His love affairs at various times were echoed in many of his works. It is notable that most of his pictures represent women, and it seems as though Picasso could "see himself only when reflected in a woman" (as the English critic John Berger observed in 1973).

At a correspondingly early stage, art-lovers and connoisseurs were forced to become familiar with the names of these women. Fernande, Eva, Olga, Marie-Thérèse, Dora, Françoise, and Jacqueline can be recognized in Picasso's

works, and the appearance of a specific lover can be matched to a certain phase in Picasso's creative life – women were, above all, sources of artistic inspiration. It is particularly intriguing to see how their differing temperaments found expression in his work, above all in the portraits of Marie-Thérèse and Dora Maar, where there is a contrast between the calm, harmonious personality of one woman and the restlessly dramatic personality of the other.

As in the case of these two women, there were often two relationships, one rapidly replacing the other in Picasso's life, and often they ran parallel. He was married only twice: first, in

Left:
Olga Koklova, 1916
Picasso met the prima ballerina Olga Koklova during work on the ballet *Parade* in Rome. In 1918 they were married according to the Russian Orthodox rites in Paris. Their son Paul (Paolo) was born in 1921. Despite their separation as a result of his open relationship with Marie-Thérèse Walter in 1935, Picasso never divorced Olga. She died in 1955.

Above:
Marie-Thérèse Walter, 1932
In 1927 Picasso approached the then 17-year-old Marie-Thérèse in the street. Up to the time of the birth of their daughter Maya in 1935, Marie-Thérèse remained Picasso's secret mistress, and only afterward did she officially share his life. After Picasso's death, Marie-Thérèse committed suicide in 1977.

Eva Gouel, 1914
In 1911, at the house of Leo and Gertrude Stein, Picasso met Eva Gouel (Marcelle Humbert), immediately fell in love with her, and the following year they moved into an apartment in Montmartre together. In December 1915 she died of tuberculosis.

1918, to the Russian dancer Olga Koklova, whom he never divorced; and then, only toward the end of his life, to Jacqueline Roque.

There must have been something exceptionally charismatic in Picasso's personality for the women in his life to have tolerated open rivalries between each other and the often humiliating situations in which they sometimes found themselves. From the reports of the participants, it is clear that he enjoyed the confrontations between these women and their

battles for his favor. Françoise Gilot wrote with some bitterness that it was "the expression of a Bluebeard complex that induced him to display in his little private museum all the women he had collected. He did not quite cut their heads off. He preferred life to go on… He was the toreador, brandishing the *muleta*, the red cloth. For an art dealer the *muleta* was another art dealer; for a woman, another woman."

It seems to be no accident that Picasso particularly admired the bullfight and its rituals. The nature of the profound, often dependent, relationships women had with Picasso may be judged by the fact that both Marie-Thérèse and Jacqueline committed suicide several years after Picasso's death.

Picasso's personal life and ambition have never been separable from his art; with his enormous self-preoccupation, he created incredible works. People, particularly women and children, were to him valued models who stimulated his

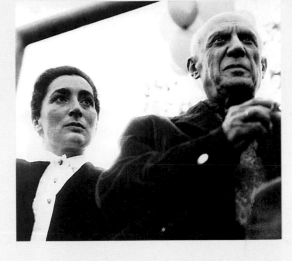

work – he transformed them into art – and it is to them that we owe some of the most powerful images in 20th-century art.

Jacqueline Roque and Picasso at a bullfight, ca. 1960
After a fleeting encounter with Jacqueline Roque in 1952, Picasso engineered a further meeting the following year. When Françoise and he separated, Jacqueline became Picasso's companion. They married in 1961, after Olga's death. In 1986, Jacqueline, who had played a leading role in administering Picasso's estate, took her own life.

Dora Maar, 1941
Dora, a Yugoslav photographer, made a photographic record of the stages of development of *Guernica* in Picasso's studio, and in the summer of 1936 she became his mistress.

Françoise Gilot, 1953
When Françoise, a painter, first met Picasso in 1943, she was 27 and he was 61. She became his long-standing companion and moved to the south of France with him. They had two children: Claude in 1947, Paloma in 1949. When persistent tensions appeared in the relationship, she left him – the only woman in Picasso's life to have left of her own accord.

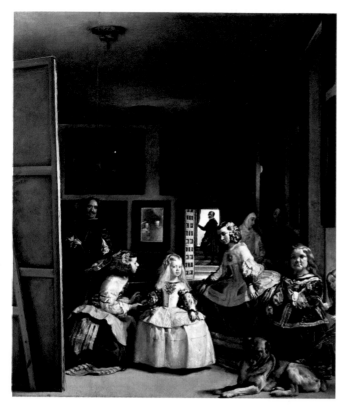

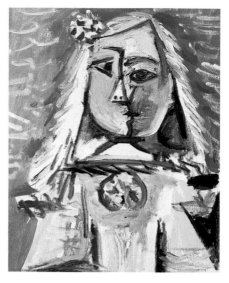

Left:
Diego Velázquez
Las Meninas, 1656
Oil on canvas
318 x 276 cm
Madrid, Museo
Nacional del Prado

Above:
**Infanta Margarita
María**, 1957
Oil on canvas
53 x 27 cm
Barcelona, Museu
Picasso

Old Masters on New Canvas

The glorification of Picasso's personality and work had an effect on him that was not always positive, for the unlimited appreciation was accompanied by reservations in critical assessments. At every phase of his life, however, Picasso had been able to draw inspiration from various sources – we need only think of the stylistic and thematic references of his early years in Paris, his encounter with primitive art during his Cubist phase, and his collaboration with other artists during his Neoclassical and Surrealistic periods.

Now, for lack of firm reference points, Picasso was withdrawing from the spotlight of general admiration; his intention was to develop, in the peace of his Mediterranean retreat, new forms of expression based on his confrontation with major works of the past.

Picasso had been producing a series of pictures in which he reworked paintings by famous predecessors since the late 1940s. This confrontation with Old Masters now

**María Augustina
Sarmiento**, 1957
Oil on canvas
46 x 37 cm
Barcelona, Museu
Picasso

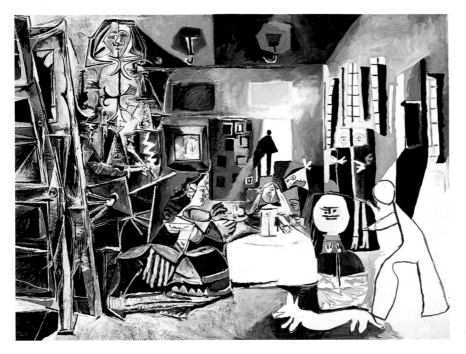

Las Meninas (after Velázquez), August 17, 1957
Oil on canvas
194 x 260 cm
Barcelona, Museu Picasso

The painter Diego Velázquez appears as a gigantic figure to the left of this picture, and all other figures are subordinated to him. Figures and space have been greatly simplified. Color and light, which for Velázquez were decisive compositional elements, are totally transformed in Picasso's version. His picture is a *grisaille* and its effect comes entirely from the contrast of gray and black areas.

In contrast to the all-powerful monarch in the 17th-century painting (the royal couple are even seen in the mirror on the wall at the back, as observers of the scene), in Picasso's work the artist is unequivocally the absolute ruler of his world – a symbol of the free and self-confident artist in a liberal modern society, a status Picasso had continually demanded.

became a fundamental theme in his late work, and he painted variations on works by Lucas Cranach, El Greco, Delacroix, Manet, Courbet, and Poussin. The original composition, color scheme, and meaning were freely at his disposal and he altered them greatly.

Between August and December 1957 Picasso created 58 variations on *Las Meninas*, a famous painting by the Spanish court painter Diego Velázquez (1599–1660). Painted in 1656, it shows the daughter of the King of Spain surrounded by her maids and ladies-in-waiting. Velázquez provides a glimpse of his studio and shows himself to the left of the picture in front of a large canvas on which he is working at

that moment. Picasso went to work in a state of positive intoxication, withdrawing for several months to the attic of his villa 'La Californie' in order to rework the theme time and again.

The early version of August 17, 1957, already includes all the essential alterations to the original that Picasso undertook (above). He reproduced the image in a broad format, and revalued the person and status of the artist in the picture by means of the size and representation of the figure. Later he heightened the impact of the painting by abandoning color in favor of gray, black, and white.

Battle for Creativity

Toward the end of his life the pace of Picasso's production became ever more hectic, and his output appeared unlimited. Up to his old age he would create between three and five paintings a day – he seemed driven to prove himself over and over again. At this time his fame was overpowering and his outstanding importance in 20th-century art unchallenged. But the latest developments in art passed him by. In the end Picasso stood on a high but very lonely pedestal.

He now restricted himself to a few themes; he concentrated mainly on established pictorial themes, already much explored in the history of art – masquerades, pairs of lovers, self-portraits, nudes. Increasingly, he also resorted to the traditional motif of the painter and his model, which he now linked with the idea that the artist's works are his children and that he bears witness to his own

Picasso and Jacqueline, 1971
Photograph by R. Cohen

Artist and Model, 1963
Oil on canvas
130 x 195 cm
Madrid, Reina Sofia

powers by begetting them. In these pictures it is often an ugly old man who gazes in wonder at the beautiful young model. Here the sexual allusions are inescapable, and in other works at this time his awareness of his waning vitality impelled him to create explicit images of couples in intimate embrace.

But there is also something fascinating about this final battle with approaching death. The unequivocal nature of the pictures makes us intimate witnesses of this mortal struggle, and the works no longer permit any distance, any cold objectivity. In the end it was as the Spanish poet García Lorca wrote: "In all countries death comes as the end. It comes, and the curtains are drawn closed. Not in Spain. In Spain the curtains are opened."

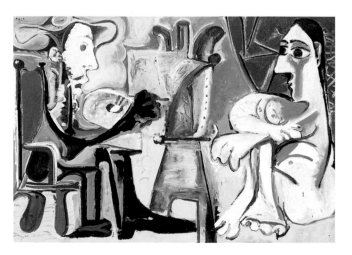

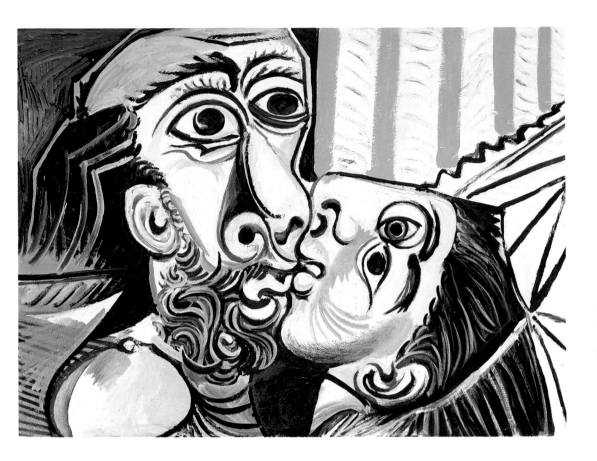

The Kiss, 1969
Oil on canvas
97 x 130 cm
Paris, Musée Picasso

In this apparently violent kiss the outlines of the two faces seem about to fuse together and yet do not. The faces themselves, which do not exhibit any recognizable emotion, are in stark contrast to the expressiveness of the style, which suggests strong emotional upheaval. The resulting impression of something concealed, suppressed, and compulsive is found in many paintings of Picasso's late period.

Drawing and painting had become more and more of a trick for him during the last decade, the trick of placing the hourglass at such an angle that the grains of sand ran down into lost time one by one.

Werner Spies, 1973

Glossary

Abstract art Art in which the depiction of objects in the world has been replaced by a concern with the purely formal elements of art – in the case of painting, for example, with such elements as shape, color, line etc. Though abstract elements are common in decoration, abstraction as an independent aesthetic principle emerged only in the 20th century. Among the major pioneers of abstract art were Wassily Kandinsky, Kasimir Malevich, and Piet Mondrian.

Art Nouveau A highly decorative style of art and design that developed during the 1890s. It is characterized by flowing lines and highly ornate plant motifs. An international movement, it influenced design, crafts, and architecture as well as painting and sculpture.

Assemblage A three-dimensional artwork that incorporates everyday objects. Early assemblages, such as those created by Picasso, are in effect three-dimensional paintings.

Avant-garde The artists who are in advance of their time, those who anticipate new developments in art and literature.

Composition The art of combining the elements of a picture into a satisfying visual whole. The elements include color, form, line, symmetry and asymmetry, movement, rhythm, etc. In landscape painting, an important element of composition is the skillful arrangement of the pictorial planes, that is, the methods that are used to inter-relate the fore-, middle and background.

Constructivism An abstract art movement of early 20th century, flourishing in particular in Russia. Arguing that art should reflect the modern world of science and technology, Constructivists sought to create paintings and sculptures using only abstract, geometrical forms, freed from any naturalistic depiction.

Contour The outline of an object painted as a line or as a contrast between two areas of color or tone.

Cubism An art movement founded by the Spanish artist Pablo Picasso and the French artist Georges Braque (from about 1907). In Cubism objects are depicted not as straightforward representations, seen from a single point of view, but as a collection of images representing a multiplicity of views.

In *Analytical Cubism* (ca. 1910–1912) images are broken down into collections of small, usually geometrical, planes or facets; in *Synthetic Cubism* (ca. 1912–1915, with echoes until well into the 1920s), there are far fewer planes, the colors are brighter, and collage is often used.

Etching A printing technique in which a design is cut into a printing plate by acid. The metal plate is covered in wax into which the design is drawn with a sharp needle. The plate is then immersed in acid, which eats into the plate where the wax has been scraped away. This creates the lines that will hold ink for printing. Etching developed in the early 16th century, so is not as old as the related technique of engraving.

Figurative A painting, drawing or sculpture, representing the human form. The term can also refer to art that (in contrast to abstract art) depicts recognizable objects.

Futurism Italian art movement led by the writer Tommaso Marinetti (1876–1944), and launched in 1909 with the publication of his *Futurist Manifesto*. Rejecting the art and culture of the past, its radical aim was to produce a totally new art that was appropriate to the modern technological world. Its dominant themes were machinery and speed.

Gouache A painting technique using water-based paints that are opaque (in contrast to watercolor). By intermixing binding agents and opaque white, a pastel-color effect is achieved, the paint drying to a matte finish.

Graphics Any of the visual arts based on drawing or the use of line rather than color. Examples include drawing, engraving, woodcut, and etching.

Grisaille A technique that involves painting entirely in one color, usually gray. In the past the technique was often used to simulate sculptural works, and then mostly for sketches and preliminary designs.

History painting The genre of painting concerned with the depiction not only of historical events but also of mythological, biblical, religious, and literary scenes. Until the end of the 19th century it was considered the most important genre of painting (it was thought morally elevating), followed by the portrait and then the "lower genres" of landscape, genre, and still-life.

Lithography A printing technique in which the printing "plate" is a block of limestone (sometimes a sheet of zinc). The design is drawn onto the plate with a greasy crayon, and the plate is then wetted. When an oil-based ink is then spread across the plate it adheres to the greasy design but is repelled by the wet surfaces. In order to make a print, a sheet of paper is now depressed onto the plate.

Motif The central theme of a work or art or literature; a recurrent thematic element or image in a work.

Neoclassicism An art style that flourished between 1750 and 1840, which was based on classical antiquity, and in particular the art and architecture of ancient Greece. One of the leading figures of this movement was the French painter Jean-Auguste-Dominique Ingres (1780-1867). It also refers to any later movement that looks back to either classical antiquity or to 18th/19th-century Neoclassicism.

Objet trouvé (French for "found object") An everyday object that has been removed from its original context and used either in, or as, an artwork, most commonly a collage or assemblage. The *objet trouvé* was used in particular by the Surrealists.

Palette A hand-held board on which paints are mixed. In an extended sense, the range of colors used by an artist.

Perspective Any method of representing three-dimensional objects on a flat surface; it is perspective that accords a picture a sense of depth. The most important form of perspective is *linear perspective* (this was first formulated by the architect Brunelleschi in the early 15th century), in which the real or suggested lines of objects converge on a *vanishing point* positioned on the horizon. The use of linear perspective had a profound effect on the development of Western art and remained unchallenged until the 20th century.

Primitivism The use in modern art of forms found in the arts of so-called "primitive" societies.

Retrospective An exhibition that presents a comprehensive selection of an artist's works, usually from all period's of his or her career.

Scraperboard A graphic medium consisting of a piece of card covered with black ink. To create a design, the artist scratches away the black surface with a sharp implement in order to reveal the white surface below.

Simultaneous perspective An approach to painting in which an object is shown from several viewpoints at once (as opposed to the single viewpoint of traditional linear perspective). The use of simultaneous perspective (sometimes seen as an attempt to capture the distinctively modern view of the world) involved the rejection of the principles of painting that had been in use since the Renaissance.

De Stijl (Dutch for "the style") A Dutch art group formed in 1917, their intention being to unite art, architecture, and design. Best known for their architectural interiors, they employed only severe geometrical forms and bright colors. These characteristics can also be seen in the paintings of the group's best-know member, Piet Mondrian (1872–1944).

Still life A painting depicting inert objects such as fruit, dead animals, flowers, or everyday objects. Early still lifes often had a symbolic meaning (eg. fading flowers representing the transience of life).

Study A preparatory drawing for a painting or sculpture. Studies can be executed in a wide variety of formats and media, and in terms of finish can range from a fleeting sketch to a detailed drawing.

Surrealism A literary and artistic movement launched in France in 1924 by the French poet André Breton (1896–1966). Rejecting conscious control as inhibiting, Surrealists attempted to draw on unconscious forces of the psyche. They created strange, disturbing, fantastical images, often by simply bringing together everyday objects in bizarre combinations.

Watercolor Water-soluble paint which dries to a transparent finish, and therefore has a particularly light, delicate effect.

Index

© 1999 Könemann Verlagsgesellschaft mbH
Bonner Straße 126, D-50968 Cologne

Editor: Peter Delius
Series Concept: Ludwig Könemann
Art Director: Peter Feierabend
Layout: Juliane Stollreiter, Peter Delius
Production: Mark Voges
Picture Research: Jens Tewes
Reproductions: Digiprint GmbH, Erfurt

Original title: Pablo Picasso

© 1999 for the English Edition: Könemann Verlagsgesellschaft mbH

Translation from German: Christine Shuttleworth in association with Goodfellow & Egan
Editing: Chris Murray in association with Goodfellow & Egan
Typesetting: Goodfellow & Egan
Project management: Jackie Dobbyne for Goodfellow & Egan Publishing Management,
Cambridge, UK
Production: Ursula Schümer
Project coordination: Nadja Bremse

This edition published by Barnes & Noble, Inc.,
by arrangement with Könemann Verlagsgesellschaft mbH

2000 Barnes & Noble Books

M 10 9 8 7 6 5 4 3 2 1

ISBN 0-7607-2159-9

Printing and binding: Sing Cheong Printing Co., Ltd., Hong Kong
Printed in Hong Kong, China

Cover
The Red Chair, 1931
Oil and enamel paint
on plywood
130.8 x 99 cm
Chicago, The Art Institute
of Chicago

Page 2
Picasso, 1933
Photograph by Man Ray

Back cover
Picasso, ca. 1930
Photograph

Acknowledgments

The publishers would like to thank the museums, archives, and photographers for permission to reproduce the illustrations and their friendly support in the creation of this book.

© Courtesy Thomas Ammann Fine Art, Zurich: 78 *r*

© Rogi André: 87 *c/l*

© Archiv für Kunst und Geschichte, Berlin: 2, 4 *t r/t c/b r*, 5 *t c/r/b l*, 7 *t r*, 12 (Photograph: Erich Lessing), 13 *t r/t l*, 17 *t*, 21 *t r*, 23 *r* (Photograph: Erich Lessing), 27 *t l*, 29, 30 *l*, 32, 33 *t l* Photograph: Otto Haeckel), ³7, 43 *t l*, 48 *b*, 55 *t r/t l/b*, 58 *t*, ⁵4 (Photograph: Erich ₌essing), 65 *t r/t l*, 68–9, 70 *b*, ₂ (Photograph: Rizzo), 73 *t* ₌ AP)/*t l*, 78 *l* (Photograph: ¹ pnitzki), 81 *l* ᵃmeraphoto Epoche), 83 *t* ₌ l, 90 *t/b*, back cover

¹998 The Art Institute of ᵢcago. All rights reserved; ᵗ of Mr. and Mrs. Daniel ₌denberg, 1957. 72: Cover,

© Artothek, Peissenberg: 36 *b r*(Photograph: Hans Hinz), 40 *b l* (Photograph: Blauel/Gnamm), 63 *b l* (Photograph: Joseph S. Martin)

© The Bancroft Library, UCLA, Berkeley: 52 *b* (Photograph: T. Bonney)

© Galerie Beyeler, Basel: 81 *t l*, 85 *b r*

© Bildarchiv Preussischer Kulturbesitz, Berlin 1998: 49 *r*, 49 *l* (Photograph: Jürgen Liepe, 1992), 53 *t l/*, 67 *r*

© Brian Brake /Photo Researchers, New York: 85 *l*

© Jean Cocteau/ Edouard Dermit: 28 *b*, 43 *t r*

© Hamburger Kunsthalle, Elke Walford Fotowerkstatt, Hamburg: 52 *t l*

© 1998 by Kunsthaus Zurich. All rights reserved: 5 *t l*, 26

© Ludwig Museum, Budapest: 5 *b r*, 82 (Photograph József Rosta)

© Collections Musée National d'Art Moderne/ Cci/Centre Georges

Pompidou, Paris: 45 *t* (Photograph: Philippe Migeat)

© Museo Nacional Centro de Arte Reina Sofia, Madrid: 69 *t/b r*

© 1998 The Museum of Modern Art, New York: 35 *t*, 66

© Museu Picasso, Barcelona; Photo Arxiu Fotogràfic de Museus, Ajuntament de Barcelona: 4 *t l*, 6, 7 *b*, 8 *r/l*, 10 *t/b*, 11, 13 *b*, 14 *t/b*, 15 *t/b*, 16 *t c*, 88 *t r/b*

© 1998 Board of Trustees, National Gallery of Art, Washington: 19

© RMN, Paris: 9 *t*, 16 *t r*, 18 *t/ b l*, 21 *b*, 22 *t r*, 23 *l* (Photograph: H. Levandowski), 27 *t r*, 33 *t r*, 35 *b*, 38 *b*, 43 *b*, 45 *b*, 47 *l*, 48 *t*, 52 *t r*, 58 *b*, 61, 62 *b*, 67 *l*, 76 *t r/ t l/b l/c/b r*, 77 *t r/l/b*, 80 *l*, 84 (Photograph: D. Arnaudet), 86 *r/ l*, 86 *c* (Photograph: Count Jean de Strelecki); (Photographs: J.G. Berizzi: 42, 50, 51, 57, 70 *t*, 75, 79 *l*, 91) Photographs: G. Blot) 60, 80

b r, 81 *t r*; (Photographs: Coursaget) 44 *t*, 46 *b*; (Photographs: B. Hatala) 4 *b l*, 20, 27 *b*, 33 *b*, 36 *t*, 38 *t*, 40 *t*, 41 *b*, 46 *t*, 54, 56 *t*, 63 *b r*, 65 *b*, 80 *t*, 81 *b r*; (Photographs: R.G. Ojeda) 34, 42 *t*, 47 *r*, 56 *b*

© Roger-Viollet, Paris: 17 *b*, 18 *c*, 22 *b*, 87 *t/b*

© Scala, Florence: 17 *b*, 24 *r/l*, 25, 30 *r*, 31, 36 *l*, 40 *b r*, 62 *t*, 63 *t r/ t l*, 71, 79 *b*, 88 *t l*, 89

© Staatsgalerie Stuttgart: 39

© The Toledo Museum of Art, Toledo: 28 *t*

All other illustrations come from the institutions named in the captions or from the editor's archives. The editor has attempted to trace and attribute the copyright for all the works illustrated. Any other persons claiming copyright are requested to inform the publishers.

Key
r = right *l* = left
t = top *b* = bottom
c = center